ADAMS MORGAN

Opposite: This early-1900s image of Ashmead Place N.W. shows very few homes on the block. There was lots of open space with clear views to the north. Today every single bit of available space is used for housing. Ashmead Place N.W. is still a very picturesque little street and is known for its friendly neighbors, beautiful homes, and lovely gardens. (Then image courtesy of Elizabeth and Christopher Naab, personal collection.)

ADAMS MORGAN

Celestino Zapata
and Josh Gibson

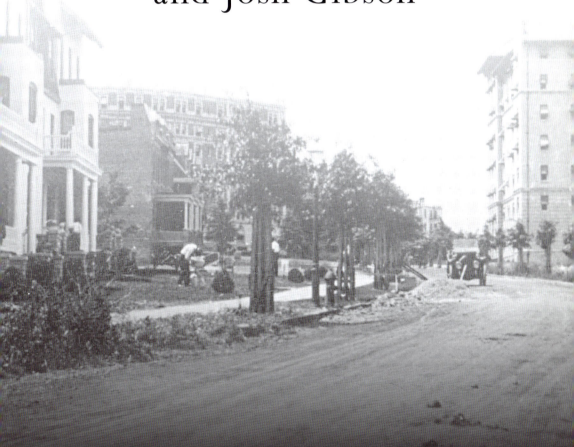

To my late father, Bill; my mother, Bobi; and my wife, Sara: you are each my past, my present, and my future. Thanks, and I love you.

To the residents of Adams Morgan: you inspire poets to write, musicians to play, and activists to bring change. To Los Zapata, especially Guadalupe Garcia Zapata and Jose Angel Zapata, Patrick M. Burkhart, Rugosa's Nebraska Cowboy, and my best friend, Damron Russell Armstrong.

Copyright © 2006 by Celestino Zapata and Josh Gibson
ISBN 978-0-7385-4283-6

Library of Congress control number: 2006923527

Published by Arcadia Publishing
Charleston, South Carolina

Printed in the United States of America

Then and Now is a registered trademark and is used under license from Salamander Books Limited

For all general information contact Arcadia Publishing at:
Telephone 843-853-2070
Fax 843-853-0044
E-mail sales@arcadiapublishing.com
For customer service and orders:
Toll-Free 1-888-313-2665

Visit us on the Internet at www.arcadiapublishing.com

On the Front Cover: Change can take place slowly over many years or in the blink of an eye. Regardless of how fast or slow things change, the comparison of "then" and "now" shows us where we've been and what we've accomplished. The two cover images compare Eighteenth Street in the mid-1950s against 2006, and we're reminded of the old adage, "the more things change, the more they stay the same." Adams Morgan residents are proud of their preservation efforts and have managed to keep bulldozers and modern structures out, thereby preserving these buildings and the neighborhood as a whole. (Then image copyright *Washington Post*; reprinted by permission of the D.C. Public Library; now image courtesy Earl Fenwick Jr.)

On the Back Cover: In this 1969 photograph, two boys fold Christmas cards at the Adams School on Nineteenth and California Streets. This image is especially telling of the wonderful diversity and camaraderie that exists in Adams Morgan.

Contents

Acknowledgments		vii
Introduction		ix
1.	Live	11
2.	Learn	39
3.	Shop	47
4.	Pray	63
5.	Play	69
6.	Make History	81

Acknowledgments

Thanks go to all the historians and the archivists—without your hard work today, yesterday would have no tomorrow. Many thanks are due to the Martin Luther King Jr. Memorial Library, especially Faye Haskins, who showed us seemingly endless patience. Special thanks also go to Mark Wright and the late Carolyn Llorente. Tremendous gratitude is owed to the exceptional team at Cultural Tourism D.C., especially Jane Freundel Levey, Laura Brower, Brendan Meyer, and Angela Fox. Many thanks go to Dr. Laura Kamoie and her American University students, who first unearthed much of the history included here. We are grateful to the Adams Morgan Partnership Business Improvement District (BID). Thanks go to Penny Engel at the Ontario and thanks to Councilmember Jim Graham and Ann H. Hargrove for their help on this project. We would also like to thank Gabriela Mossi and Avner Ofer at Adams Morgan Main Street and Peter Wolfe and Tony Harvey at the *InTowner* for their moral support.

Introduction

Adams Morgan is a study in contradiction. It is named for two once-segregated schools, yet it is remembered for the biracial cooperation of their principals and others to improve the community. It prides itself on being the polar opposite of the homogenous cookie-cutter suburbs, yet it itself was once a suburb. It rightfully decries and fears gentrification as being right around the corner, though it has been doing so for nearly five decades, and despite the fact that before the neighborhood was rich it was poor, but before it was poor, it was originally rich.

In the earliest days of what is now called Adams Morgan, Native Americans clustered around Rock Creek. When the District of Columbia was established, it had a more traditional, state-like geography. Today the City of Washington and the District of Columbia share identical borders, but when the first permanent white residents came to today's Adams Morgan, they lived to the northeast of the town of Georgetown and due north of the city of Washington, just across Boundary Street (today's Florida Avenue) in the County of Washington in the District of Columbia.

In an area of the District knows for its comparative elevation and resultant cool breezes (coincidentally or not, the adjacent neighborhood is called Mount Pleasant), diplomat Joel Barlow charmingly dubbed his early-19th-century home Kalorama, Greek for "beautiful view." Though his early Adams Morgan estate does not survive, almost two centuries later, Kalorama lent its name to a historical district and an attractive, tree-lined street. Even today, the neighborhood's perch on the hill provides excellent downhill views of downtown.

For decades, elevation was destiny for the area that would later become Adams Morgan. The horse-drawn streetcars that allowed for the expansion of the city of Washington were unable to climb to Adams Morgan's heights, so it was only with the creation of the electric streetcar that today's Adams Morgan area became literally and financially attainable to a broader group of residents. Then and only then could Adams Morgan become one of the first "streetcar suburbs."

In the period between Kalorama and the streetcar suburb, much of the neighborhood's development came as a result of the single-minded efforts of Mary Foote Henderson, the wife of a Missouri senator and a dedicated crusader for the early neighborhood. As a result of Henderson's efforts, Sixteenth Street grew in prominence, her magnificent and now-lamented home and castle were built, Meridian Hill Park was created, plans for an Adams Morgan–based Lincoln Memorial and palatially expanded White House were floated, a variety of embassies were convinced to locate on the fringes of today's Adams Morgan. The diplomatic, social, and tourist traffic these embassies created, in addition to the choice of many embassy employees to live near work in some of Adams Morgan's earliest apartment homes, provided the first seeds for the diversity that has long been synonymous with what we today call Adams Morgan.

From a purely economic perspective, the high point of Adams Morgan's history lasted from the 1900 to the 1960s. The apartment buildings recognized as D.C.'s "best addresses" were built during that time

(mainly in the first two decades of the 20th century); the neighborhood's toniest businesses, including Gartenhaus Furs and baker-to-the-presidents Avignone Freres, had their white-gloved heyday during this period. It was also during this period that gentlemen named Dwight Eisenhower, John F. Kennedy, Harry Truman, and Lyndon Johnson called Adams Morgan home.

In the 1960s and 1970s, in Adams Morgan as in America in general, riots and protests were the order of the day. With the growing availability of automobiles in the 1950s, it became increasingly possible to move out of and beyond Adams Morgan, and with the unrest of the 1960s, some felt that moving out was advisable. Many of the protest groups of the period, from the Weathermen to the American Indian Movement to the Black Power effort, found homes and welcome ears in Adams Morgan. From an economic standpoint, the car-driven exodus, combined with the unrest, made Adams Morgan an increasingly affordable housing option for radicals, charitable causes, and ethnic groups of all stripes.

Yet some remnants of the neighborhood's tonier days had stayed in place and felt threatened, so in conjunction with development-minded city and national interests, they concocted a freeway-based urban renewal project meant to eliminate what they considered to be decayed architecture and unsavory elements of the population. Only concerted community action across racial lines saved Adams Morgan from this fate.

In the 1980s and 1990s, many new faces came to the neighborhood's main commercial corridors of Eighteenth Street and Columbia Road. The neighborhood's reputation as an ethnic dining mecca was solidified during this period, and the neighborhood became more and more broadly known as "the place to be" in the D.C. area, particularly at night.

What the 21st century will bring is unclear. All that is certain is that the keystones of Adams Morgan's history—change and diversity—will continue to be the community's lifeblood. What is past is present.

CHAPTER 1

LIVE

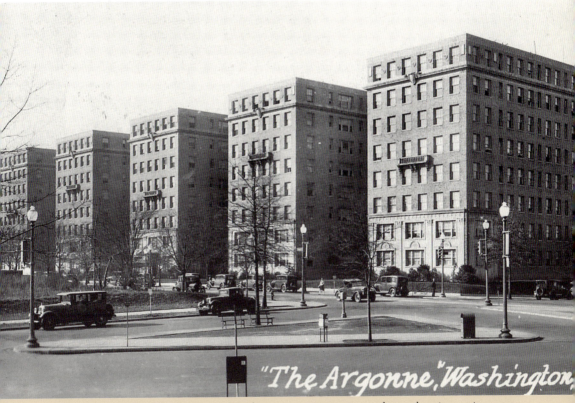

If there is one thing Adams Morgan residents know how to do, it is live! This vibrant and fascinating neighborhood provides for a quality of life enjoyed by few others. It charms with its beauty, fascinates with its history, throbs with music, entices with the scents and flavors of its cuisine, and provides a unique, mom-and-pop shopping environment that successfully separates visitors and residents alike from their hard-earned cash every day of the week. (Then image courtesy Jerry McCoy, personal collection)

This home, at 1827 Belmont Road, was once a music school, as shown in this early photograph. Today it is home to Ann and Larry Hargrove. Ann Hargrove was previously Advisory Neighborhood Commission chair and a key District Council staff member. She was a key leader in the effort to defeat urban renewal plans for Adams Morgan. Both Ann and her husband remain active in neighborhood issues today. (Then image courtesy Ann H. Hargrove; Now image courtesy Earl Fenwick Jr.)

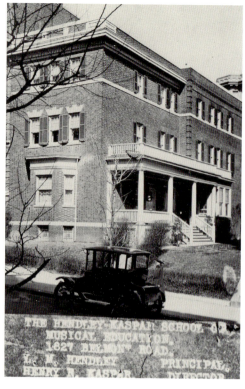

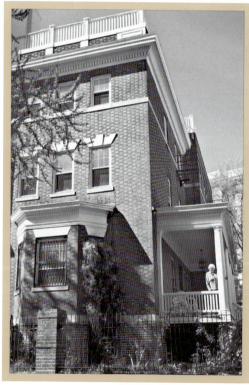

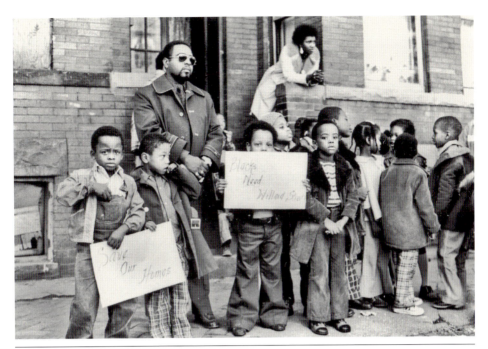

Willard Street and Seaton Street, at the southern end of Adams Morgan, are narrow and home to tiny but lovely homes with an interesting history. Located in the Strivers' Section Historic District, many of these homes were originally home to working-class African Americans in the early 20th century. As the racial mix in the neighborhood shifted, many homes in this area became subject to racial covenants that forbade their sale to African Americans. Such covenants were struck down by the Supreme Court in 1948. During the urban renewal era, the area's traditional population was again threatened, since a freeway was planned to replace this "difficult" neighborhood. (Then image courtesy Nancy Shia; Now image courtesy Earl Fenwick Jr.)

LIVE

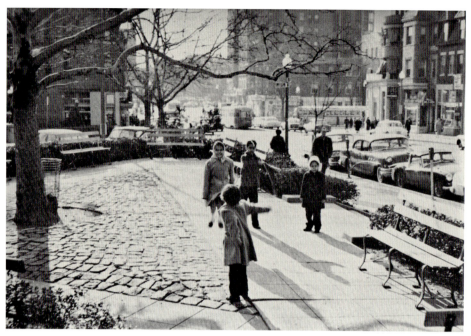

This small, triangular park was once part of the parcel now home to the First Church of Christ, Scientist. The church donated it to the community. In proof that what is old is new, current city transportation plans suggest closing the narrow, one-way street between the church and the park, again unifying the parcel. Unity Park is now home to a well-intentioned but roundly criticized sculpture and a monumental flock of pigeons. With its benches, shrubs, and historic paving, the older iteration seems more welcoming than today's. (Then image courtesy Ann H. Hargrove; Now image courtesy Earl Fenwick Jr.)

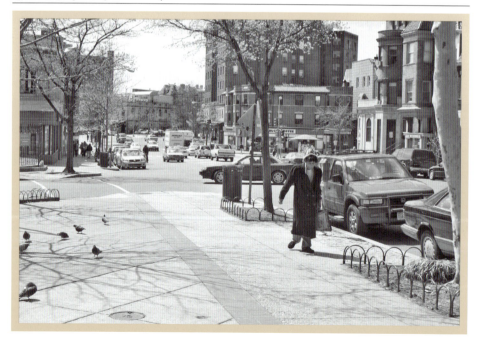

In a precursor of today's teen hipsters hanging out at the record store at the mall, these bell-bottomed disco hombres set the scene in front of the Latino record store Bazar Nelly, located at 1766 Columbia Road N.W. Despite the fairly recent vintage of the period photograph, it does provide evidence that some industries' heydays have come and gone—while Adams Morgan was once home to at least two television repair shops, both are now shuttered. (Then image courtesy Nancy Shia; Now image courtesy Earl Fenwick Jr.)

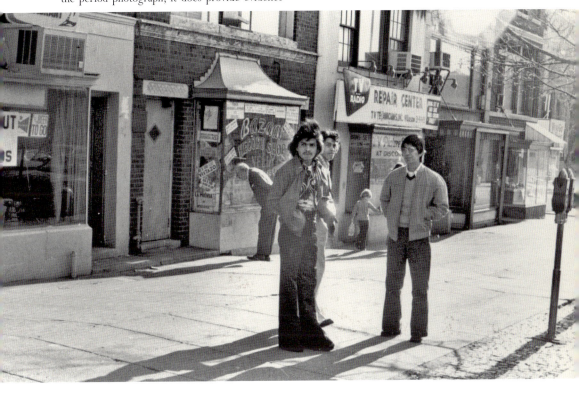

LIVE

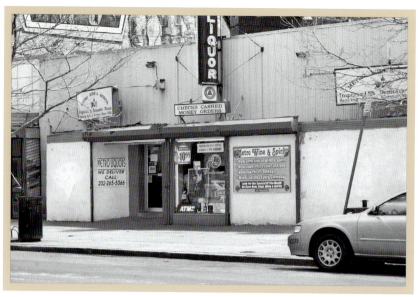

In this memory from when the city's Latino Festival was held on Columbia Road, we see what it would look like if Carmen Miranda, a color photocopier, and a fun house mirror had a collision. Latin beauties of all colors, sizes, and shapes parade in front of a liquor store that has changed little in the intervening years. Note how in the period photograph, the phone number for the store is still listed in the old alphanumeric fashion, with the "CO" representing Columbia Road. (Then image courtesy Nancy Shia; Now image courtesy Earl Fenwick Jr.)

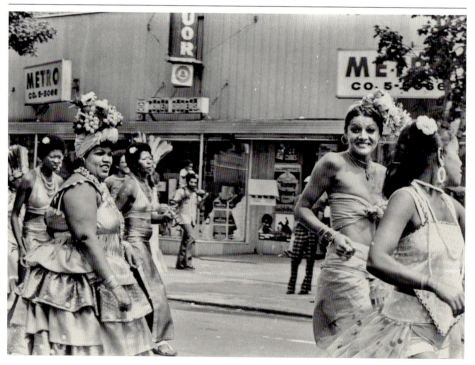

In this Columbia Road streetscape, we see how much and how little changes in Adams Morgan. The Anglo chicken joint at left is now a Latino chicken joint, the bus stop in the older photograph now has a full-fledged bus shelter, and the campaign posters for Betty Ann Kane have been replaced by posters for a popular line of clothing. At right in the older photograph, the Giant, once located immediately adjacent to the Safeway, is visible. (Then image courtesy Nancy Shia; Now image courtesy Earl Fenwick Jr.)

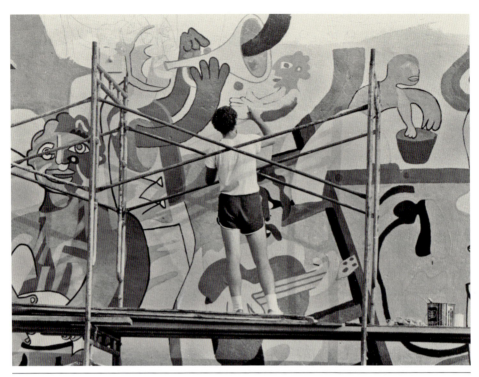

Adams Morgan is home to many murals. The oldest, painted in 1977 by Chileans Carlos Salazar and Felipe Martinez, lies just steps from the Eighteenth Street and Columbia Road intersection. To the left of the main mural, a whimsical caption reminds us, in English and Spanish: "A people without murals is a demuralized [sic] people." In 2005, Juan Pineda fully revitalized the mural. (Then image courtesy Nancy Shia; Now image courtesy Earl Fenwick Jr.)

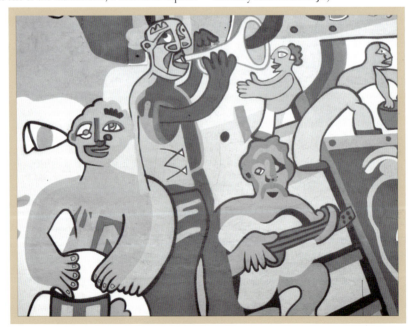

It is important to remember that quiet, tree-lined streets (Mintwood Place is shown here in 1959) are as much a part of Adams Morgan as the vibrant shopping and nightlife of the main commercial corridors. As shown here, other than the year, make, and model of the surrounding cars, far less change takes place on these side streets. (Then image copyright *Washington Post*, reprinted by permission of the D.C. Public Library; Now image courtesy Earl Fenwick Jr.)

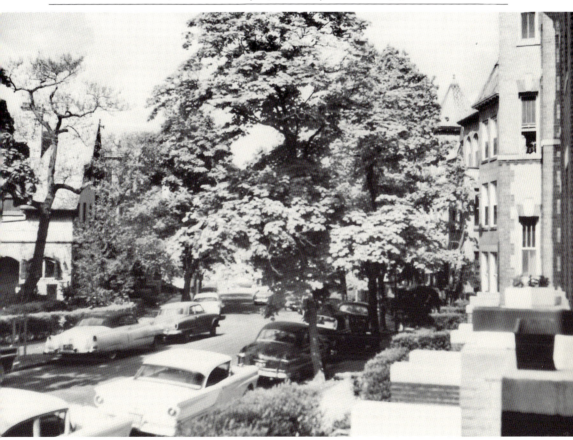

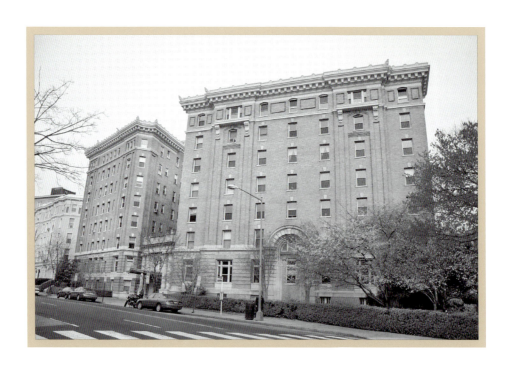

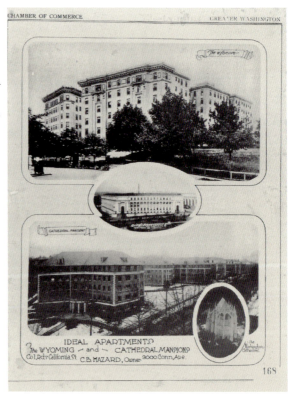

This 1920s advertisement flatters the Wyoming Apartments, 2022 Columbia Road N.W., and the Cathedral Mansions with its comparisons to the landmark City Post Office and the Washington Cathedral. The Wyoming, one of D.C.'s "best addresses," provides a stark architectural contrast with one of its more recent neighbors, the Washington Hilton. The Hilton once sought to have the Wyoming razed and replaced with a hotel expansion, but this effort was defeated through concerted community action. The Cathedral Mansions lie just north of Adams Morgan. (Then image Washingtoniana Division, D.C. Public Library; Now image courtesy Earl Fenwick Jr.)

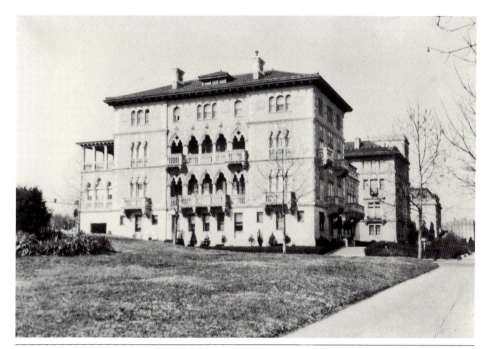

This building at 2600 Sixteenth Street N.W. was once labeled "the Pink Palace" and was once residence to Secretary of the Treasury and Mrs. MacVeagh, former secretary and Mrs. Straus, and then to Mrs. Marshall Field in 1912. Built by George Oakley Totten Jr. in 1906, this Venetian Gothic–style home (with additions added 1912 and 1988) is now the headquarters of the Inter-American Defense Board (IADB). The IADB, founded in 1942, provides for the cooperative defense of the Western Hemisphere under the aegis of the Organization of American States. (Then image Washingtoniana Division, D.C. Public Library; Now image courtesy Earl Fenwick Jr.)

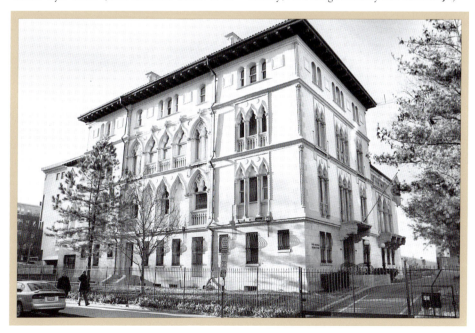

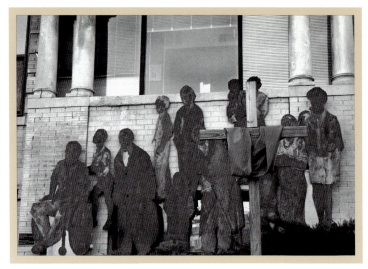

Art imitates life in this pair of pictures located at 1717 Columbia Road N.W. In the earlier shot, a diverse group of men clusters on the steps, and in the modern photograph, the group of men has been replaced by artistic silhouettes. Christ House, headquartered in this building since 1985, provides quality medical care to the homeless population of Adams Morgan and the surrounding communities. (Then image courtesy Nancy Shia; Now image courtesy Earl Fenwick Jr.)

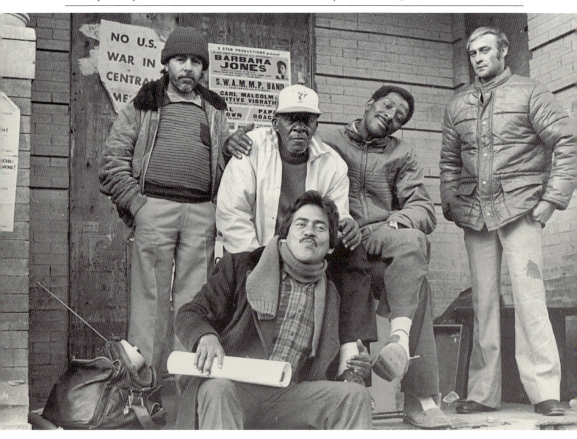

In this pair of images of 1717 Columbia Road, the entire building can be seen in a decrepit state, with windows smashed and the door boarded over. At first glance, it would appear abandoned, but the building was in fact home to many Adams Morgan homeless. The Cuban Refugee Crisis of the late 1970s and early 1980s, landed some of those individuals in Adams Morgan, and the building became known as "the Cuban Embassy." The organization Christ House returned the building to productive use on December 24, 1985, when they began providing the homeless with much-needed medical attention and services. (Then image courtesy Nancy Shia; Now image courtesy Earl Fenwick Jr.)

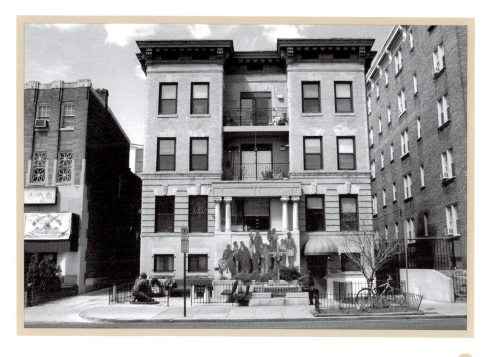

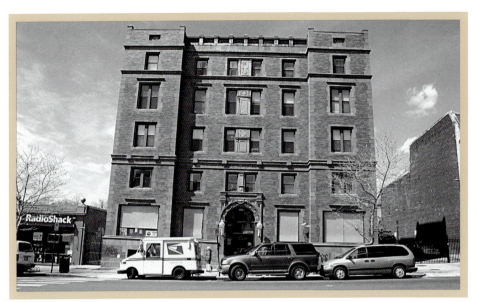

The Imperial, located at 1763 Columbia Road N.W., is one of east Columbia Road's most striking apartment buildings. It experienced a significant downturn between the heyday of its construction and its current pristine appearance. A landlord-tenant dispute around 1980 led to protests and eventually to the building being vacated and falling into disrepair. During this low period, the building was in a sad state, with boarded-over windows casting a pallor over the entire block. In 1984, the building reopened as home to luxury apartments and office space. (Then image courtesy Nancy Shia; Now image courtesy Earl Fenwick Jr.)

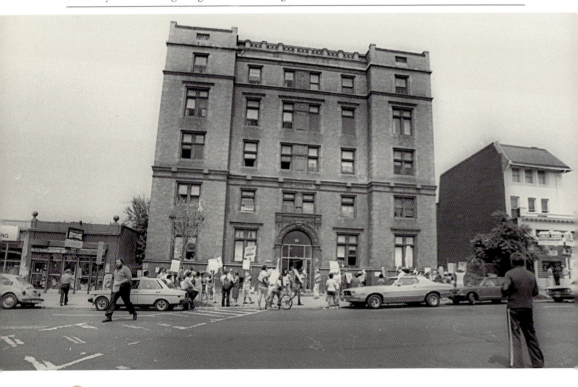

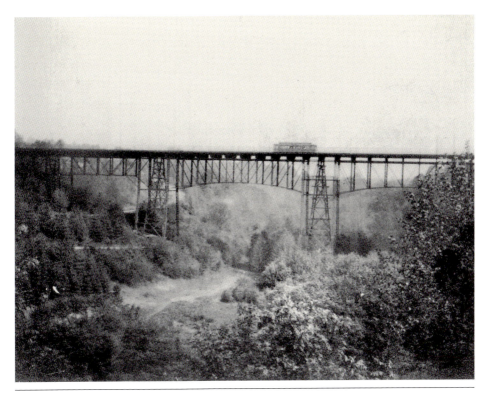

This early streetcar bridge spanned Rock Creek Park from east to west. In 1934, the entire bridge was moved 80 feet south and was replaced by a masonry bridge known today as Duke Ellington Bridge. (Then image Washingtoniana Division, D.C. Public Library; Now image courtesy Earl Fenwick Jr.)

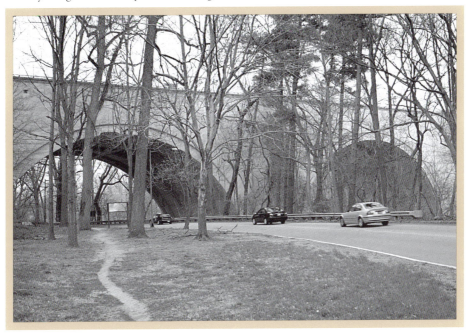

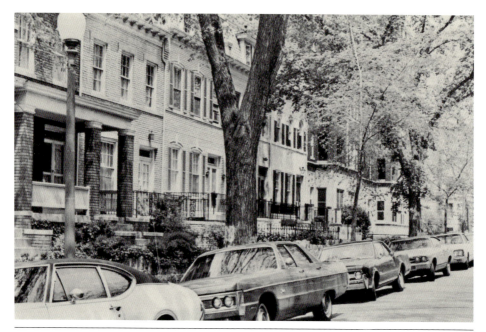

The placid and bucolic appearance of Lanier Place can be deceptive—not only is this street just a half block from the hectic Eighteenth Street and Columbia Road intersection, but it is also home to much history. The street was for many decades home to a large Jewish population, including the parents of *The Jazz Singer*'s Al Jolson. During the turbulent 1960s and 1970s, the Black Panthers, American Indian Movement, and Students for a Democratic Society were welcomed on the street. Suspected U.S. Capitol bomber Leslie Bacon was chased by the FBI across the roofs of several homes here. (Then image copyright *Washington Post*, reprinted by permission of the D.C. Public Library; Now image courtesy Earl Fenwick Jr.)

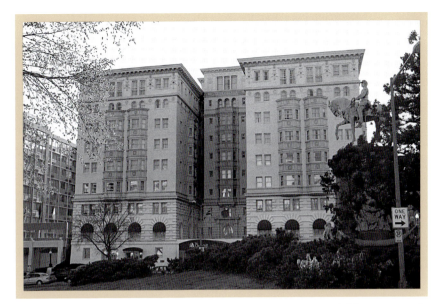

Glancing across Connecticut Avenue, Adams Morgan's western boundary, the Churchill Hotel dominates the landscape. Formerly the Highland Apartments, today the Churchill looks across the street at a statue of fellow warrior George McClellan, a Civil War general. (Then image Washingtoniana Division, D.C. Public Library; Now image courtesy Earl Fenwick Jr.)

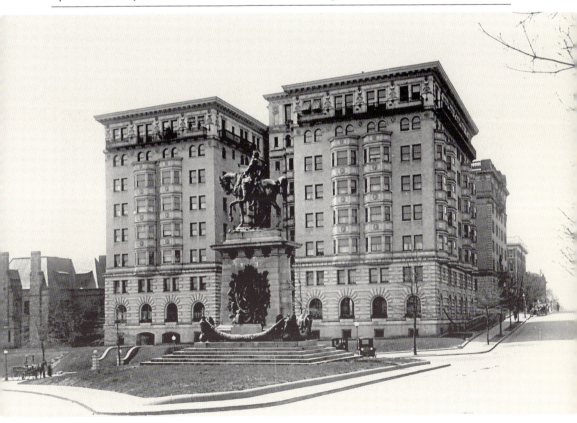

LIVE

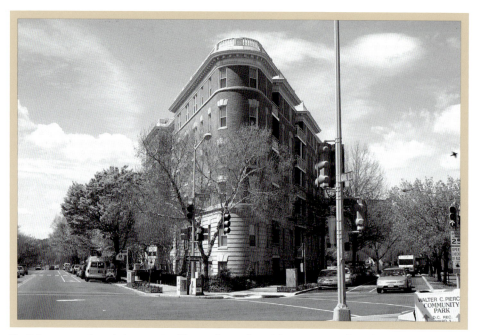

Firefighters struggle to bring a raging blaze under control at the Beacon, on the corner of Adams Mill Road and Calvert Street. Partially in response to this fire, the District changed its building codes to disallow in-unit washers/dryers under some conditions—this fire was tied to lint from a clothes dryer. The Beacon is today informally known as "La Barca," Spanish for "the boat," since the Flatiron-like point at the front of the building resembles the prow of a ship. (Then image courtesy Nancy Shia; Now image courtesy Earl Fenwick Jr.)

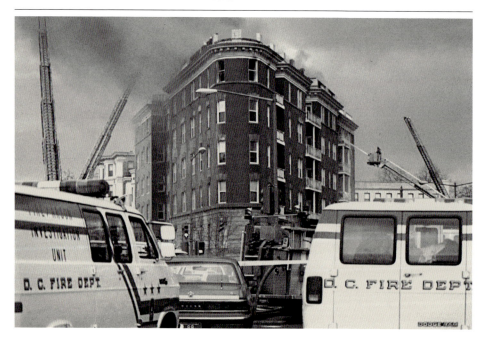

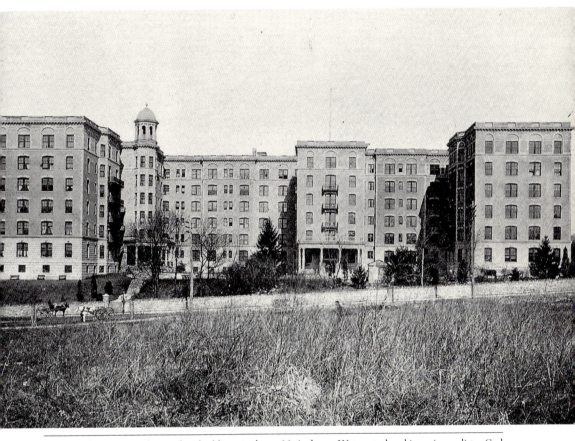

One of Adams Morgan's proudest buildings is the Ontario (2853 Ontario Road N.W.) built just after the turn of the century. This building, a cooperative, has long been home to some of the capital's most prestigious residents, including Gen. Douglas McArthur, Watergate-breaking journalist Carl Bernstein, and the current District councilmember for Adams Morgan and the rest of Ward One, Jim Graham. (Then image courtesy Jim Graham; Now image courtesy Earl Fenwick Jr.)

First chartered in 1978 as a spin-off of the Gay Men's VD Clinic, the Whitman Walker Clinic is a Washington institution. It provided pioneering AIDS care in the years prior to the identification of the disease and expanded its services to include medical, housing, and food services during the worst of the epidemic. For much of the 1980s, Whitman Walker operated from this location at 2335 Eighteenth Street. Jim Graham, today councilmember for Adams Morgan, was the longtime executive director of Whitman Walker. (Then image courtesy Jim Graham; Now image courtesy Earl Fenwick Jr.)

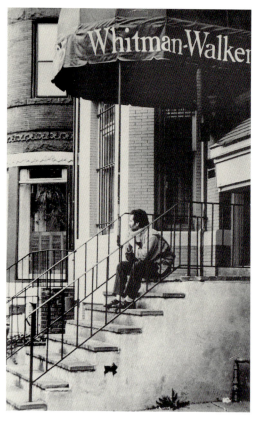

Construction comes in waves in Adams Morgan, as it does everywhere. The most recent wave began in the late 1990s and continues today. One of the first and largest new residential developments was the building in the now photograph, Adams Row, located at the corner of Kalorama Road N.W. and Champlain Street N.W. now home to 68 condos. The building it replaced housed a ground-floor grocery and liquor store for decades, plus apartments upstairs. (Then image courtesy Ann H. Hargrove; Now image courtesy Earl Fenwick Jr.)

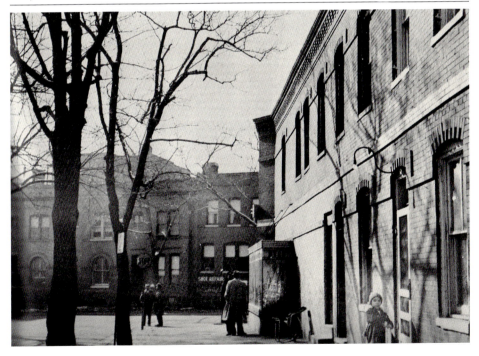

The elegant French architecture of the Meridian House (1630 Cresent Place N.W.) calls to mind the Seventh Arrondissement of Paris more than Washington, D.C., but the unexpected surprises of Adams Morgan architecture are part of what makes the neighborhood such a wonderful discovery. Today the Meridian House and the adjacent White-Meyer House provide a home to the intercultural education programs at the Meridian International Center. (Then image Washingtoniana Division, D.C. Public Library; Now image courtesy Earl Fenwick Jr.)

Famed architect John Russell Pope, designer of the Lincoln Memorial, National Archives, and the original National Gallery of Art building, is also behind the Meridian House and White-Meyer house (partially shown at left). Both buildings today house the Meridian International Center, a nonprofit organization dedicated to promoting international understanding. (Then image Washingtoniana Division, D.C. Public Library; Now image courtesy Earl Fenwick Jr.)

It would appear that the typesetter transposed the captions on these urban renewal era then-and-now sketches. This is not the case, however—at the time, the narrow and homogenous row houses were seen as being squalid, outdated, and inefficient. The high-rises shown in the proposed "after" were seen to be futuristic and hygienic. Due to concerted community action, the urban renewal process that overtook Southwest D.C. was avoided here. (Then image courtesy Ann H. Hargrove; Now image courtesy Earl Fenwick Jr.)

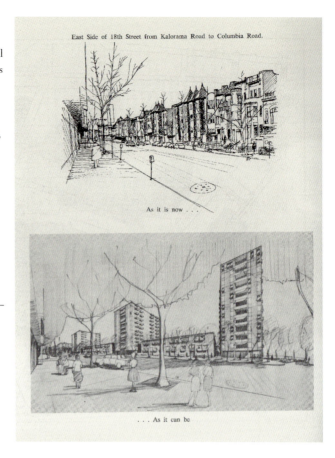

East Side of 18th Street from Kalorama Road to Columbia Road.

As it is now . . .

. . . As it can be

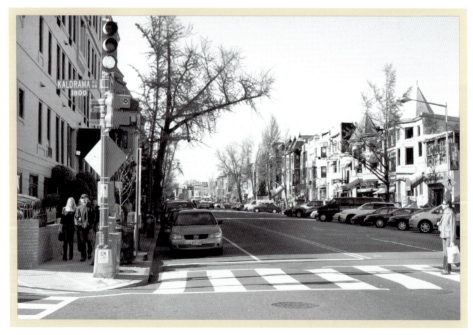

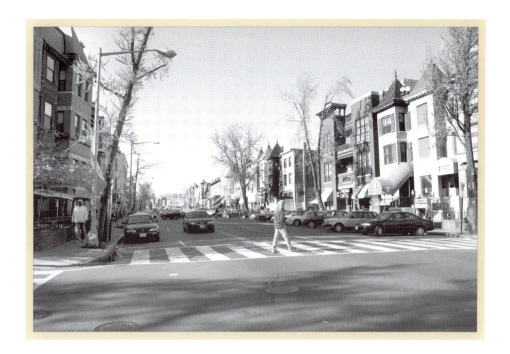

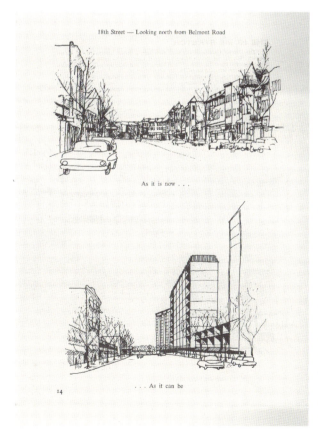

18th Street — Looking north from Belmont Road

As it is now . . .

. . . As it can be

14

In another seemingly backward display of how the neighborhood is today and how it could be, a diverse and historic mix of architectural styles faces demolition, to be replaced by a tiresome sameness. Most agree today that urban renewal was not only meant to stomp out architectural diversity, but racial and economic diversity as well. (Then image courtesy Ann H. Hargrove; Now image courtesy Earl Fenwick Jr.)

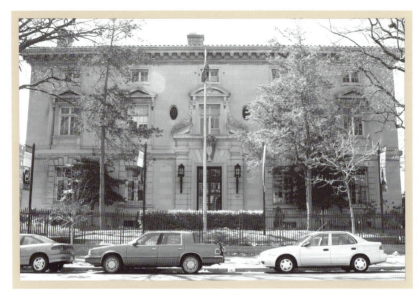

The Italian Embassy is one of the foreign delegations convinced to locate on Sixteenth Street by the always-persuasive Mary Foote Henderson. After decades of successful diplomatic service, these historic quarters grew too small, and the embassy relocated to a larger and more modern structure on Whitehaven Street, N.W. At the time of publication, a residential condominium conversion known as Il Palazzo was pending. (Then image copyright *Washington Post*; reprinted by permission of the D.C. Public Library; Now image courtesy Earl Fenwick Jr.)

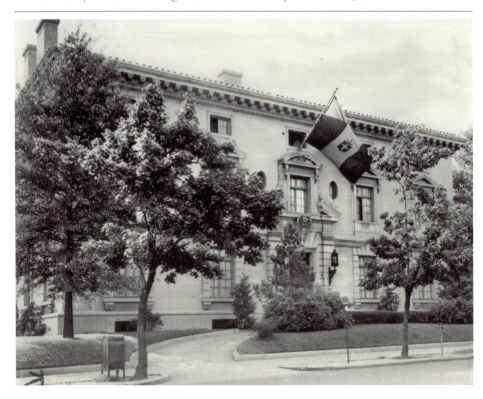

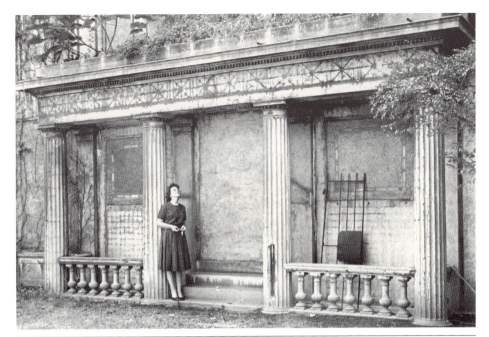

This fabulous portico is lost from public view today. Once the primary entrance to the home, it was bricked over; the home has since been demolished. This facade lies behind today's Washington House Apartments on Florida Avenue. Unfortunately this type of demolition in the name of progress is all too common. This photograph is the only information found in the archive; the story never ran. (Then image copyright *Washington Post*, reprinted by permission of the D.C. Public Library; Now image courtesy Earl Fenwick Jr.)

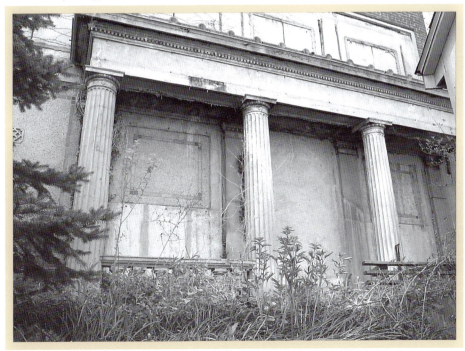

If 1970s Adams Morgan had a house band, it likely would have looked like this. This group, whose name is lost to history, embodies the diverse, freewheeling, harmonious spirit that perpetually pulses through the veins of our community. (Then image courtesy Nancy Shia; Now image courtesy Earl Fenwick Jr.)

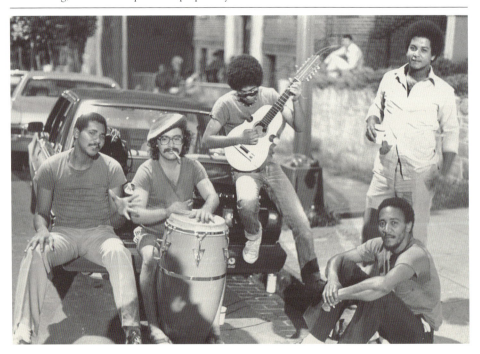

CHAPTER 2

LEARN

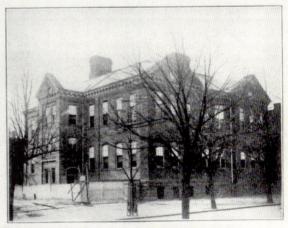

ADAMS SCHOOL, WASHINGTON, D. C.

It is impossible to recount Adams Morgan's history without mentioning its schools. During the era of desegregation that followed the Supreme Court's *Brown v. Board of Education* decision, the principals of the all-white John Quincy Adams School and the all–African American Thomas P. Morgan School came together to discuss how to tackle neighborhood issues. Thus a neighborhood moniker was born. (Then image Washingtoniana Division, D.C. Public Library; Now image courtesy Earl Fenwick Jr.)

39

Once an all-white establishment that gave Adams Morgan half of its name, the Adams School has a student body that is today split between African Americans and Latinos. In this 1969 photograph, a little girl prepares greeting cards wishing people "A Black Christmas." (Then image copyright *Washington Post*, reprinted by permission of the D.C. Public Library; Now image courtesy Earl Fenwick Jr.)

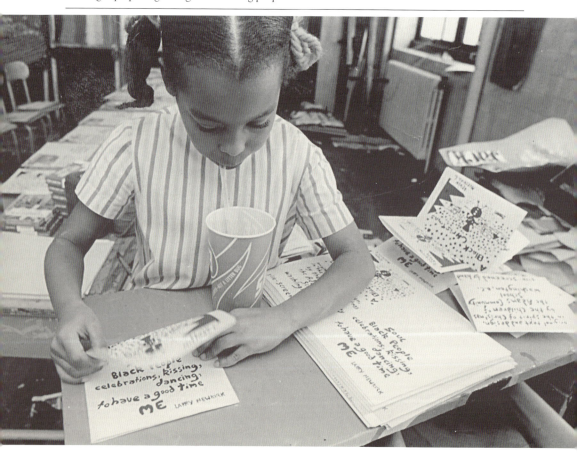

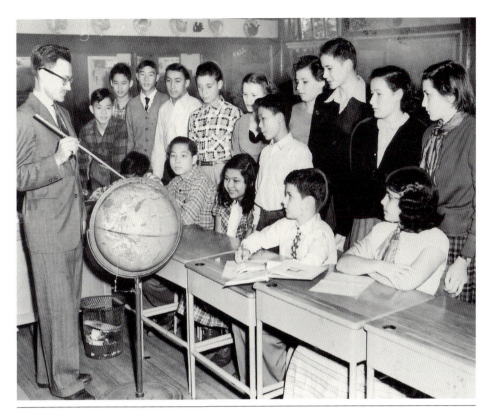

Young faces from around the world crowd around a globe at what was known as "the Americanization School" that operated at the Adams School from 1949 to 1967. Lessons on Thanksgiving were also apparently on the menu in this classroom at that time. Though today the Adams School is simply an American— not an Americanization—school, it is still home to a rainbow of international faces. (Then image copyright *Washington Post*, reprinted by permission of the D.C. Public Library; Now image courtesy Earl Fenwick Jr.)

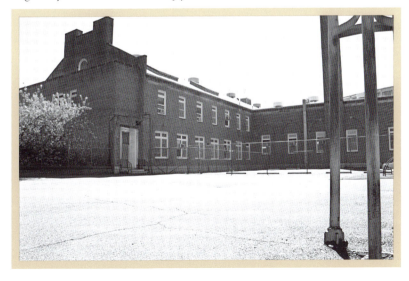

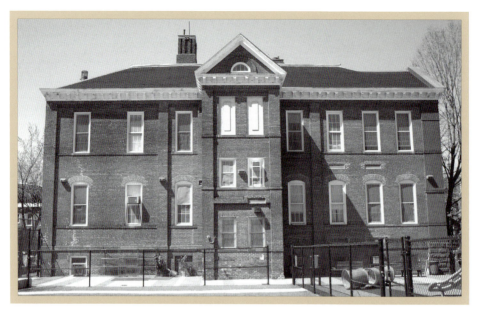

This, the original Adams School, lies several blocks south of the present-day school's location, on R Street between Seventeenth and Eighteenth Streets. Today this school is known as the Ross School. As recently as a couple of decades ago, Adams Morgan was considered to extend as far south as R Street. Today the boundaries of the neighborhood are commonly accepted as being U Street on the south, Connecticut Avenue on the west, Harvard Street on the north, and Sixteenth Street on the east. (Then image Washingtoniana Division, D.C. Public Library; Now image courtesy Earl Fenwick Jr.)

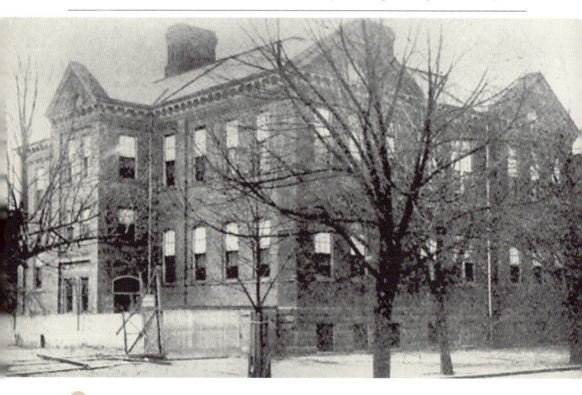

The partnership between these two boys is a metaphor for the historic school partnership that gave Adams Morgan its name. In this 1969 photograph, the children work on assembling "Black Christmas" greeting cards. The diversity of the neighborhood frequently leads to such cross-cultural moments, even cross-cultural business ownership, such as the Korean-owned Jewish deli or the restaurant described by the local weekly *Washington City Paper* as "Creole cooking done by an Iranian who is married to a Korean—delivered to your table, often as not, by an Eritrean or Ethiopian waitress." (Then image copyright *Washington Post*; reprinted by permission of the D.C. Public Library; Now image courtesy Earl Fenwick Jr.)

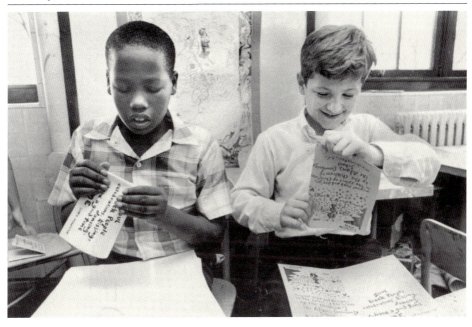

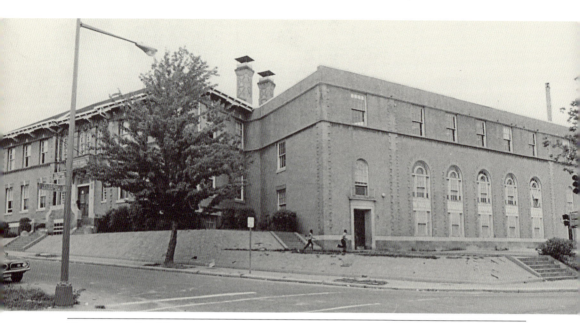

The corner of California Street and Florida Avenue was home to the Thomas P. Morgan School. Home now to a sports field. Note another of the neighborhood's distinctive murals at bottom right of the modern photograph. (Then image copyright *Washington Post*, reprinted by permission of the D.C. Public Library; Now image courtesy Earl Fenwick Jr.)

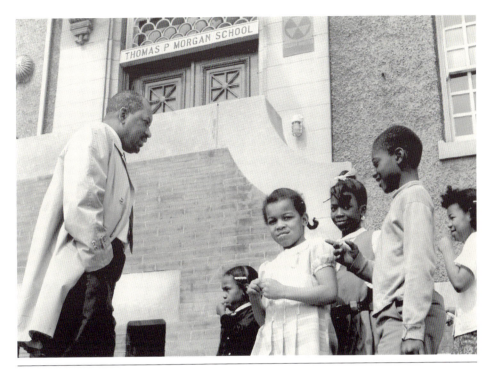

The Thomas P. Morgan School, the formerly all–African American school that gave Adams Morgan half its name, fell into disrepair and was demolished. The sport field of the Marie H. Reed Community Learning Center lies where the Morgan School once stood. The stately home of District commissioner Thomas P. Morgan once lay not far away on the site where the Washington Hilton is now located. (Then image copyright *Washington Post*, reprinted by permission of the D.C. Public Library; Now image courtesy Earl Fenwick Jr.)

LEARN

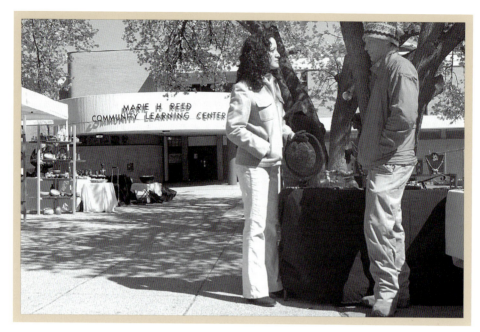

Seemingly hardened against a hypothetical future assault, the Marie H. Reed Community Learning Center (2200 Champlain Street N.W.) lies under construction here. It was built to replace the adjacent, all–African American Thomas P. Morgan School. The Reed Center is a one-stop government service center, home to a school, health clinic, and recreation center. In the modern photograph (taken where the large tree at the far left is in the older photograph), the organizers of Western Market, a weekly crafts fair, discuss the event's success. (Then image copyright *Washington Post*; reprinted by permission of the D.C. Public Library; Now image courtesy Earl Fenwick Jr.)

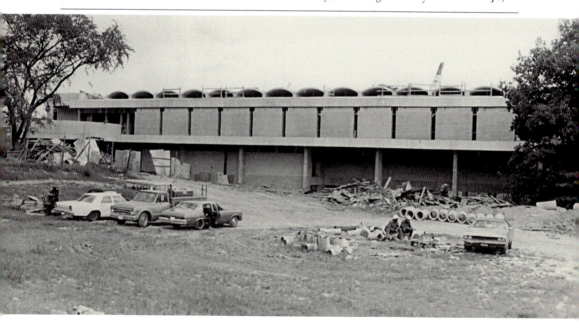

CHAPTER 3

SHOP

Before it was known as Adams Morgan, this community was named for the two streets whose intersection forms its core: Eighteenth Street and Columbia Road. Both have long histories as great places to shop, eat, and enjoy the nightlife. Fur shops and fine bakeries yielded to natural food co-ops and galleries, which in turn gave way to bodegas, designer furniture stores, and ethnic restaurants of every stripe. (Then image courtesy Jerry McCoy, personal collection.)

Two generations of reggae style pose at this mid-Eighteenth Street location. The Green Door Emporium, a thrift shop located at 2414 Eighteenth Street, is now home to a newsstand and arcade. Many small and interesting shops line Eighteenth Street, and B and K News Stand is one of the most colorful. (Then image courtesy Nancy Shia; Now image courtesy Earl Fenwick Jr.)

In this 1962 photograph of the east side of Eighteenth Street, streetcar tracks are still present, but the car is clearly already king. The gas station at the far left of the older photograph (absent in another earlier view of that intersection) reinforces this fact. In the modern photograph, nothing (other than the Madam's Organ mural) is clearer than the increased prominence of the automobile. (Then image copyright *Washington Post*, reprinted by permission of the D.C. Public Library; Now image courtesy Earl Fenwick Jr.)

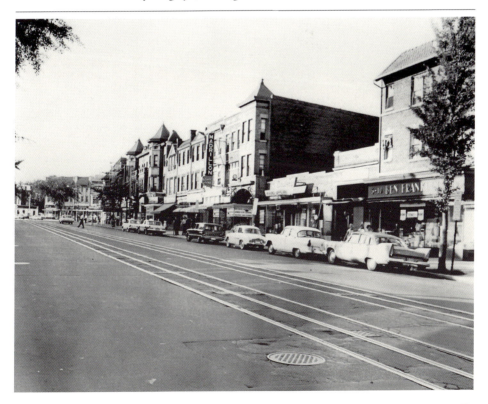

SHOP

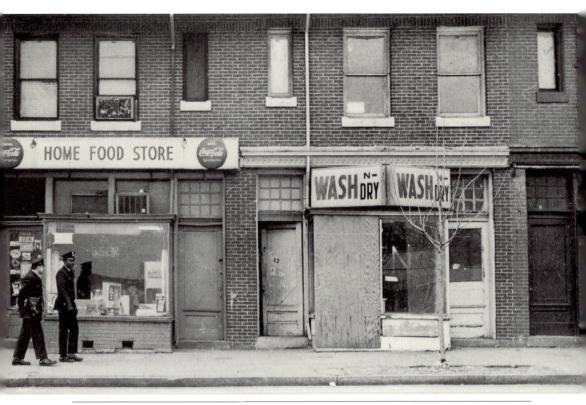

Only the neighbors seem to have changed in this 1974 photograph. While the Home Food Store still sells a full range of Coca-Cola products and cigarettes, the retail spaces next to it now house an Ethiopian restaurant, a Latino seafood eatery, and the Rendezvous Lounge. In an amazing coincidence, the Wash-n-Dry Laundromat has been replaced with Awash Ethiopian Restaurant. Awash is the name of a river, a market town, and a national park in Ethiopia. (Then image copyright *Washington Post*, reprinted by permission of the D.C. Public Library; Now image courtesy Earl Fenwick Jr.)

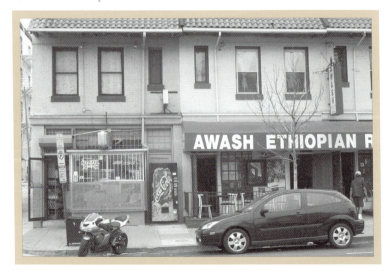

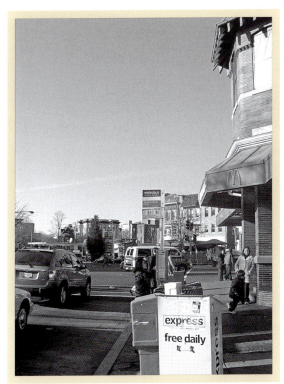

While the bus stop remains from this 1936 photograph, much else has changed at the southeast corner of Adams Morgan's key intersection of Eighteenth Street and Columbia Road. Longtime local drugstore chain Peoples Drug was replaced by a McDonalds in the landmark Waddy Wood structure. Looking into the background of the photograph, on Adams Mill Road, the four buildings at right remain, with the others having been replaced by a gas station and an alley. (Then image Washingtoniana Division, D.C. Public Library; Now image courtesy Earl Fenwick Jr.)

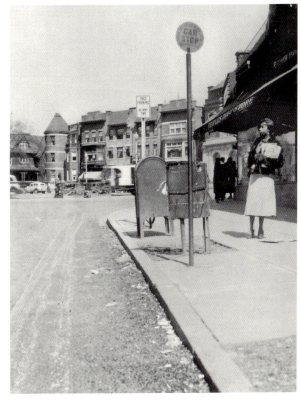

SHOP

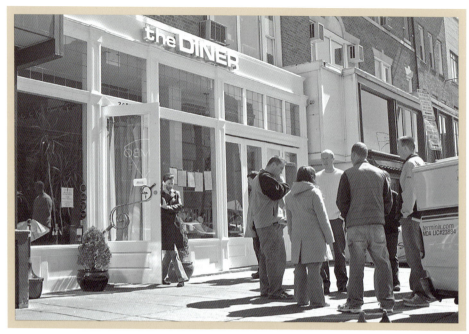

Few establishments evoke the same nostalgia among Adams Morgan old-timers as this 1974 image of the Ben Franklin five-and-dime. Though today's Adams Morgan is full of dollar stores, the romantic memory of the old five-and-dimes remains. After a long stretch as an auto parts shop, a trendy new diner (called the Diner) is now slinging malteds and real soda fountain vanilla Cokes. Maybe the 1950s never ended after all. (Then image copyright *Washington Post*, reprinted by permission of the D.C. Public Library; Now image courtesy Earl Fenwick Jr.)

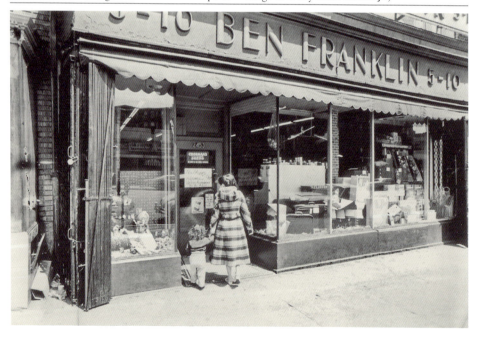

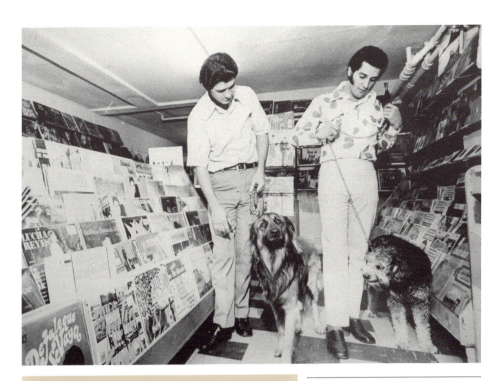

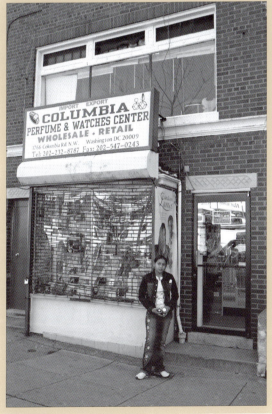

Two groovy dudes and their hip disco dogs check out stacks of wax at Latino record store Bazar Nelly. Today this location is home to a store selling perfume and watches. The young lady standing in the now image models fragrances in front of the store. The format may have changed from records to CDs and MP3s, but Adams Morgan still pulses with ethnic and off-the-beaten-path music. (Then image copyright *Washington Post*, reprinted by permission of the D.C. Public Library; Now image courtesy Earl Fenwick Jr.)

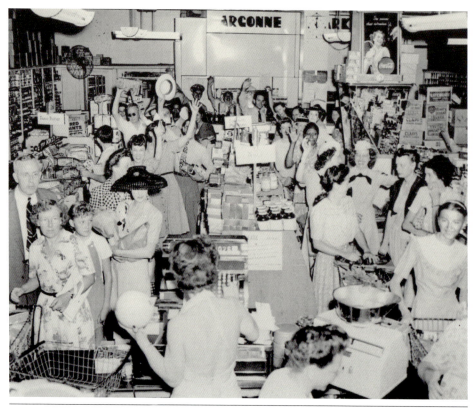

On VJ Day, August 15, 1945, the day celebrating victory over Japan and the end of World War II, a diverse cross-section of Adams Morgan exults while in line at the Argonne Market at 1813 Columbia Road. Today Todito grocery store, a Latino owned and operated business, still provides the neighborhood with a little bit of everything. (Then image copyright *Washington Post*, reprinted by permission of the D.C. Public Library; Now image courtesy Earl Fenwick Jr.)

Adams Morgan is a neighborhood that is always changing but that has respect for its own history. The one-time location of low-key neighborhood hangout and live music venue Columbia Station was demolished and replaced by a new mixed-use building that is home to the ultra-sleek, design-minded retailer Design Within Reach. When local businessman Mehari Woldemariam sought a name for his new jazz club, he dubbed it Columbia Station. (Then image courtesy Nancy Shia; Now image courtesy Earl Fenwick Jr.)

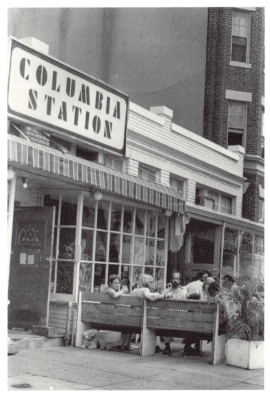

Pictured here is beloved neighborhood hangout Columbia Station. In a neighborhood as ethnically diverse as Adams Morgan, live music is an obvious and necessary fact of life. Cuban, West African reggae, and vintage bluegrass music are just some of the auditory options pleasing the ears of residents and visitors on a weekly basis. (Then image courtesy Nancy Shia; Now image courtesy Earl Fenwick Jr.)

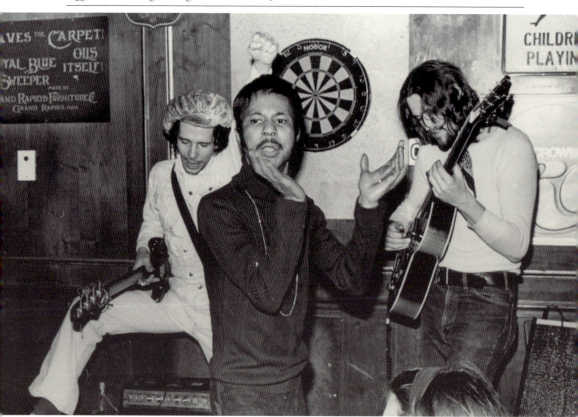

Scenes like this seldom draw much attention in Adams Morgan. While this photograph may have been taken on Halloween, it might not have. Whether a movie shoot (*Dave*, *In the Line of Fire*, *A Few Good Men*, and *Enemy of the State* all had scenes shot here), a 20-horse contingent of mounted police, a stray galloping horse, or an ambling camel, none of these draw more than slightly elevated attention from Adams Morgan regulars. (Then image courtesy Nancy Shia; Now image courtesy Earl Fenwick Jr.)

SHOP

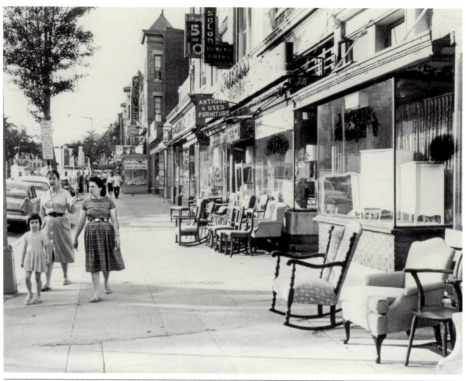

Over time, the identity of Eighteenth Street has continued to change. What was initially a residential street gave way to shops, nonprofit offices, and arts spaces, as is pictured in the first of two photographs here. Starting in the 1980s and continuing to today, while the street retains many vibrant retailers, restaurants and bars predominate. Visible in this photograph is one of the neighborhood's rightfully famous murals. This one depicts a 25-foot-tall madam, beloved emblem of Madam's Organ, a renowned soul-food and live-music establishment. (Then image copyright *Washington Post*, reprinted by permission of the D.C. Public Library; Now image courtesy Earl Fenwick Jr.)

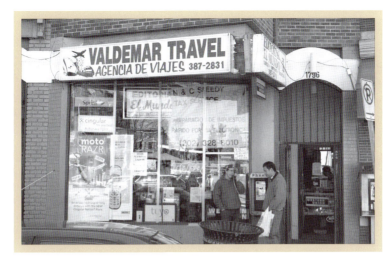

This 1974 photograph of Eddie Ottenstein's newsstand shows available titles reflecting the perennial diversity of the surrounding community. In addition to the standard newsstand fare, *Jet* and *Essence* are joined in their prominent placement by two Italian papers. This photograph was part of a larger story that covered other small businesses in Adams Morgan, including Caridad Lebrato of Casa Lebrato and Jack Littlejohn. Today's newsstand focuses primarily on Spanish-language titles. (Then image copyright *Washington Post*, reprinted by permission of the D.C. Public Library; Now image courtesy Earl Fenwick Jr.)

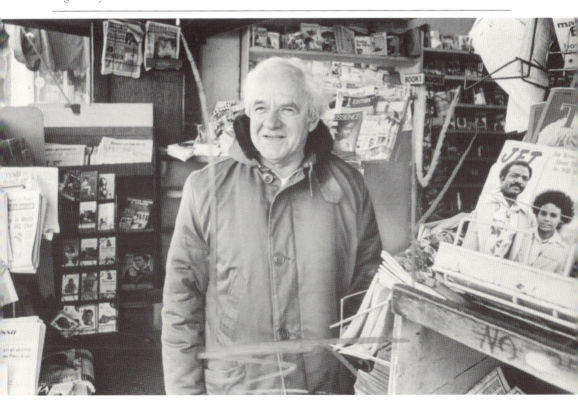

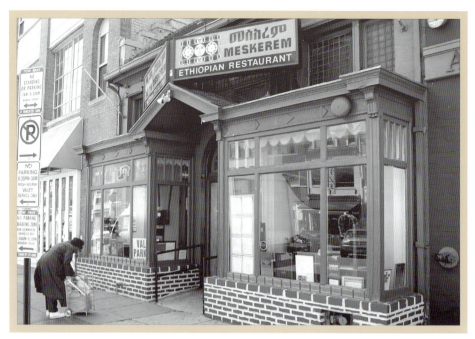

From mail to melt-in-your-mouth goodness, the post office has transformed into one of Adams Morgan's better-known and longest-lived Ethiopian restaurants. It is said that Washington is home to the highest concentration of Ethiopian restaurants outside of the home country, and Adams Morgan was long the heart of D.C.'s Ethiopian (and later also Eritrean) population. That population center is now gradually moving east to U Street. (Then image courtesy Nancy Shia; Now image courtesy Earl Fenwick Jr.)

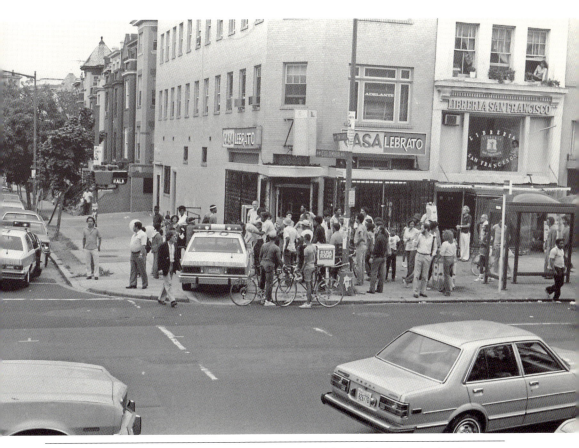

Since this photograph was taken, not much has changed. This Latino corner grocery, or bodega, still remains in place, though its ownership is now Korean. From a political standpoint, little has changed as well. Adams Morgan remains a center of liberal political thought, though is it now more often home to protest planners than to the protests themselves. (Then image courtesy Nancy Shia; Now image courtesy Earl Fenwick Jr.)

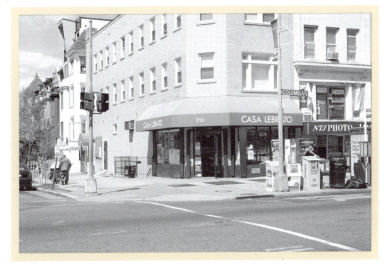

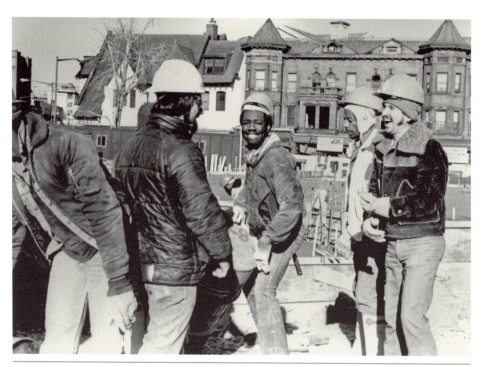

Few locations in Adams Morgan have seen such change as the southwest corner of Eighteenth Street and Columbia Road, so it is not unusual that it is shown in transition here. Former home to the Knickerbocker and Ambassador Theatres, and site of a tragic roof collapse that killed nearly 100, this lot is shown while under construction. The site now features a bank and a privately owned plaza that is home to a beloved weekly farmer's market. (Then image courtesy Nancy Shia; Now image courtesy Earl Fenwick Jr.)

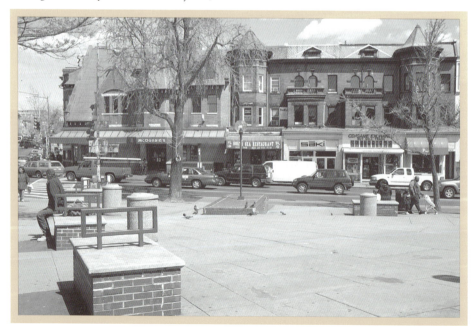

CHAPTER 4

Pray

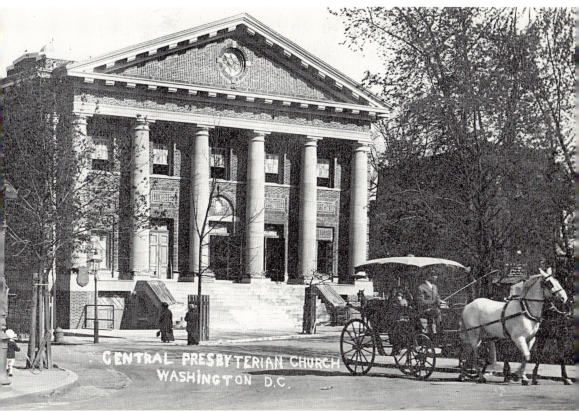

One longtime motto of Adams Morgan proclaims "Unity in Diversity." Adams Morgan even features a diversity of divinities. From Baptist to Unitarian to Methodist to Church of Christ, Scientist, it's all here. One Eighteenth Street shop even sells the herbs, candles, and figurines tied to the Santeria faith. In one truly only-in-Adams-Morgan locale, a church built by the Mormons and directly across the street from Methodist and Unitarian churches was converted in 1977 to a place of worship for the Reverend Sun Myung Moon's Unification church. (Then image courtesy Jerry McCoy, personal collection.)

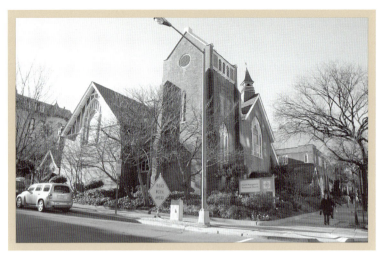

Just outside Adams Morgan's boundaries lies St. Margaret's Episcopal Church. The church is perhaps best known today for its extensive social and charitable mission, including Charlie's Place, a breakfast program for the homeless that is housed in the church. This program was founded by the Reverend Charles Gilchrist, a Maryland state senator and Montgomery County executive who worked as an Episcopal priest during his political retirement and served as an associate rector at St. Margaret's. (Then image copyright *Washington Post*, reprinted by permission of the D.C. Public Library; Now image courtesy Earl Fenwick Jr.)

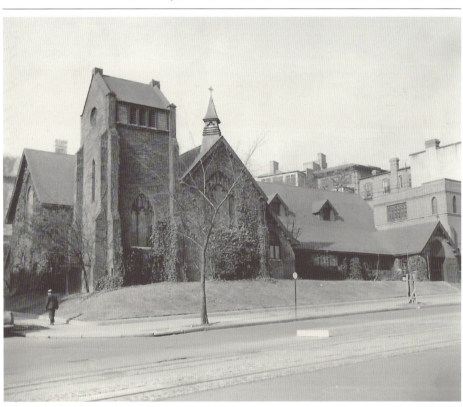

In this 1974 photograph, city residents look across Sixteenth Street, the District's key north/south axis, at All Souls Unitarian Church. The park where they sit, part of the Rock Creek Park system, is known as Rabaut Park after late Michigan congressman Louis Rabaut. Locals refer to it in familiar but less loving terms as "Rat Park" or "Pigeon Park." An effort is underway to rename it Romero Park after the slain, crusading Salvadoran archbishop Oscar Romero. (Then image Washingtoniana Division, D.C. Public Library; Now image courtesy Earl Fenwick Jr.)

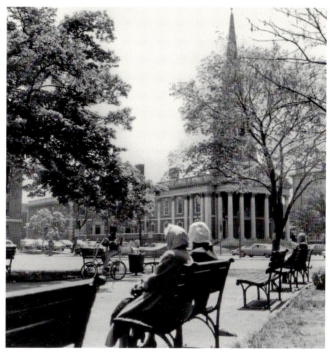

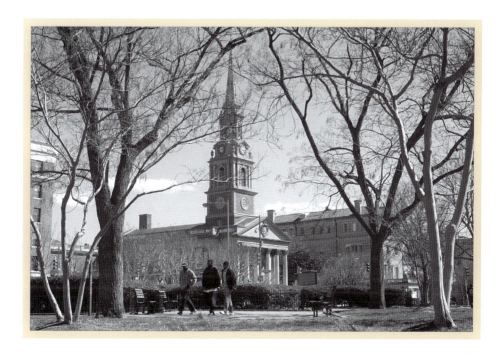

The tower of the National Baptist Memorial Church is just one of the three dramatic spires that grace the intersection of Sixteenth Street and Columbia Road. In all, dozens of religious structures create a divine line-up along Sixteenth Street from the White House to the Maryland border. (Then image copyright *Washington Post*, reprinted by permission of the D.C. Public Library; Now image courtesy Earl Fenwick Jr.)

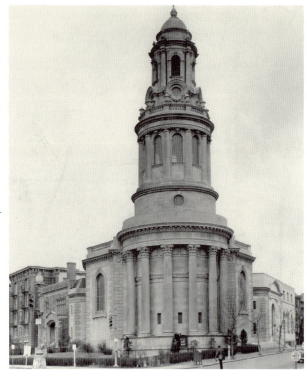

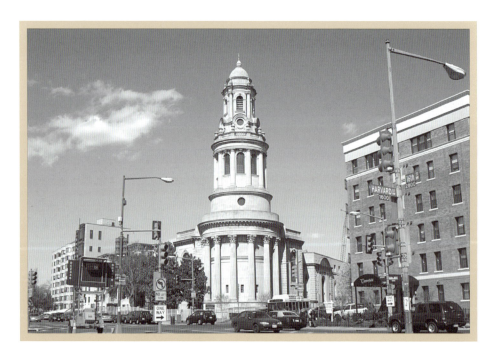

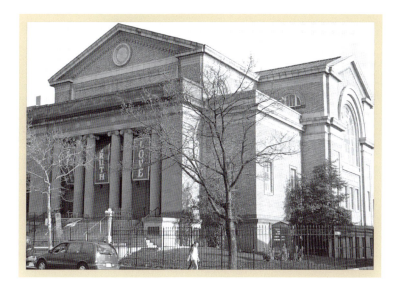

This church, the most monumental of those located within the neighborhood boundaries, was opened to the public in 1912. In the aftermath of the tragic Knickerbocker Theatre roof collapse in 1922, the church was used as a first aid and triage station as well as a morgue. Today the basement of the church is home to a help group for at-risk youth called Urban Rangers, which uses the space to rehabilitate donated bicycles. Due to the church's shrinking congregation, the historic structure is currently slated to be renovated into condominiums. (Then image Washingtoniana Division, D.C. Public Library; Now image courtesy Earl Fenwick Jr.)

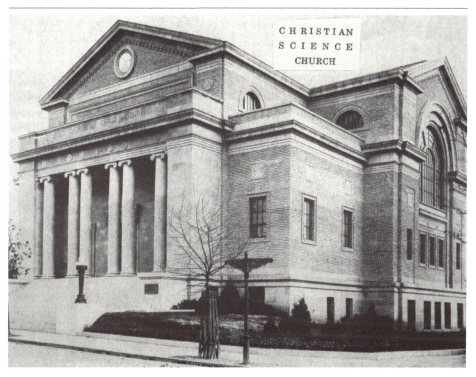

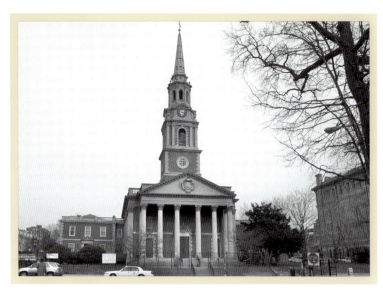

Originally founded as the First Unitarian Church in 1822, All Souls Unitarian Church has remained a bastion of progressive social and political thought ever since. The church defines itself as "a diverse, spirit-growing, justice-seeking community." From slavery to civil rights to apartheid, from World Wars I and II to Vietnam, All Souls has been on the forefront of the issues of the day. The church has been in its current building since 1923. (Then image copyright *Washington Post*, reprinted by permission of the D.C. Public Library; Now image courtesy Earl Fenwick Jr.)

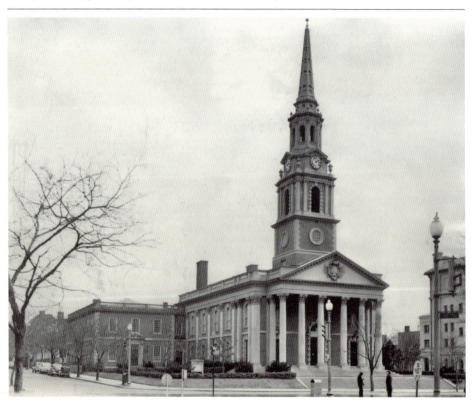

CHAPTER 5

PLAY

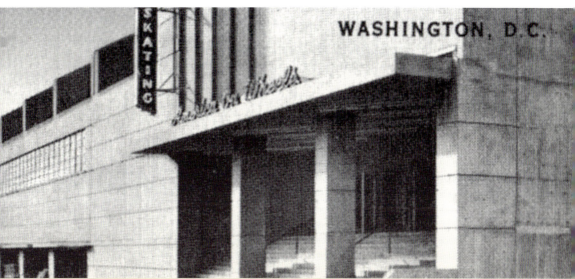

In Adams Morgan, people have very different ways of enjoying themselves. Some head outdoors and glory in the neighborhood's prominent parks. Others head indoors, enjoying domestic and international music and dancing of every known variety. For those who are lovers of both music and the great outdoors, there are clearly two obvious answers: festivals and parades. One of the community's primary festivals, Adams Morgan Day, grew so large it was moved to broader and more crowd-compatible Pennsylvania Avenue. The other main festival is nearing its 30th year, and moved from Columbia Road to Eighteenth Street to expand the available booth and walking spaces. (Then image courtesy Jerry McCoy, personal collection.)

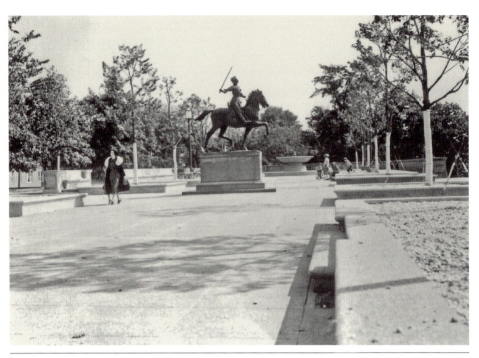

Joan of Arc, the Maid of Orleans, seems to lead D.C.'s highlands to war against its lowlands. Just beyond the wall at right, the land drops precipitously, as it does citywide across the geological feature known as the escarpment. The statue of Joan, the only female equestrian statue in D.C., was a gift from the Ladies of France in Exile to the nation in 1922. (Then image copyright *Washington Post*, reprinted by permission of the D.C. Public Library; Now image courtesy Earl Fenwick Jr.)

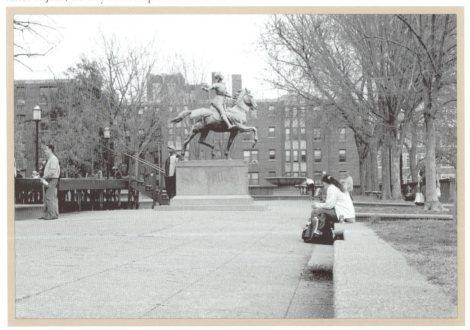

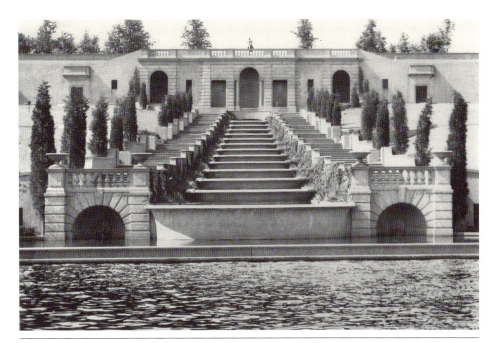

The cascade at Meridian Hill/Malcolm X Park evokes the splendor of European palaces. A statue of Joan of Arc on horseback gazes down from above. The park was home to strollers and classical music concerts for the first two-thirds of the 20th century, protests in the 1960s and 1970s, drugs, sex, and degradation in the 1980s, and rebirth in the 1990s. Thanks to community advocacy groups and the National Park Service, which owns the park, it was rehabilitated, and Pres. Bill Clinton held an event here in 1994 commemorating the 25th anniversary of Earth Day. (Then image copyright *Washington Post*, reprinted by permission of the D.C. Public Library; Now image courtesy Earl Fenwick Jr.)

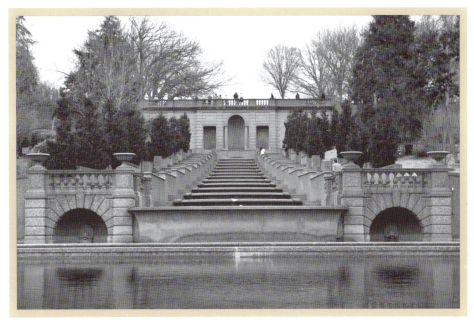

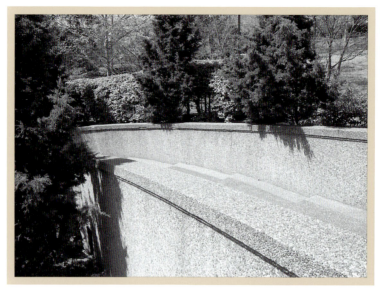

An ethnic cross-section of Adams Morgan residents and neighbors enjoy a concert in Meridian Hill/Malcolm X Park in 1941, frequently a feature of the park in decades past. In the modern-day photograph, the pleasing, flowing geometry of the park's walls can be seen, as can the composite nature of the concrete. This kind of concrete, which incorporates pea gravel, saw one of its very first uses at this park. The steps had yet to be poured in the older photograph where the modern photograph shows the pea-gravel steps. (Then image copyright *Washington Post*, reprinted by permission of the D.C. Public Library; Now image courtesy Earl Fenwick Jr.)

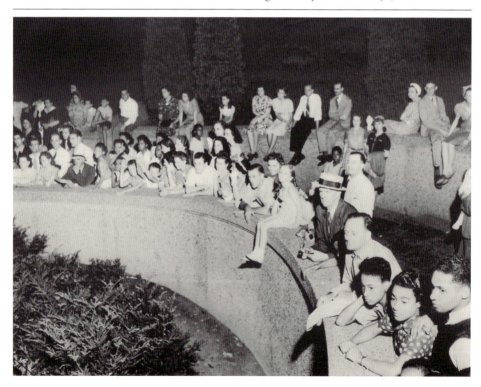

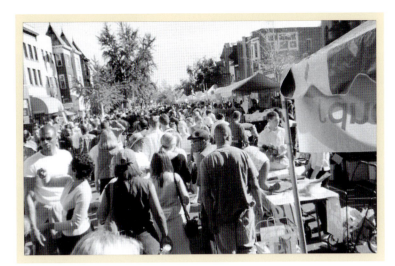

In this Adams Morgan Day photograph from the days when the event was still held on Columbia Road, we see a number of fashion faux pas: big glasses, gold-rimmed sunglasses, short shorts, tight pants, sideburns, and big hair. Fortunately only about half of these have come back into style. The restaurant shown in the background, Perry's, is still home to a popular Sunday morning drag brunch, where the performers are always dressed to the nines. (Then image courtesy Nancy Shia; Now image courtesy Earl Fenwick Jr.)

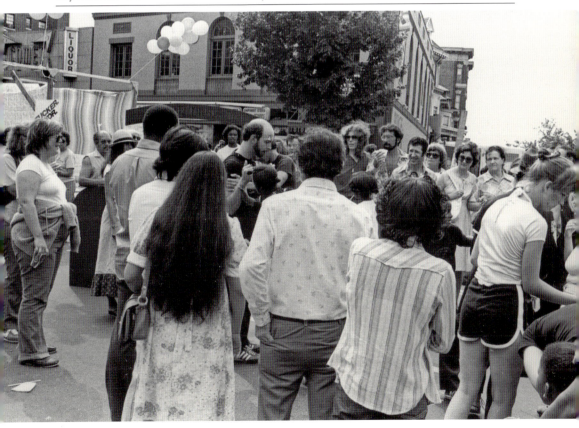

PLAY

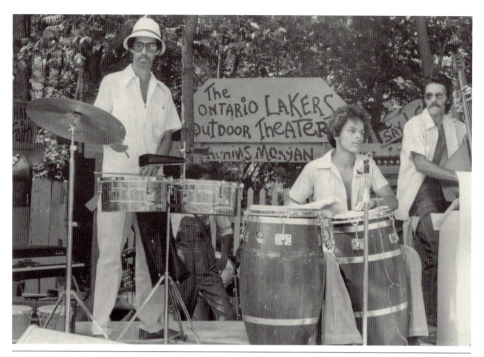

The area known today as Walter Pierce Park, a former residential development and cemetery site, was initially known by the less-memorable moniker Community Park West. It was renamed to honor Walter Pierce, a community resident active in the movement to create the park. Pierce also founded the Ontario Lakers (Ontario Place is across from the park), a now-dormant local youth group. (Then image courtesy Nancy Shia; Now image courtesy Earl Fenwick Jr.)

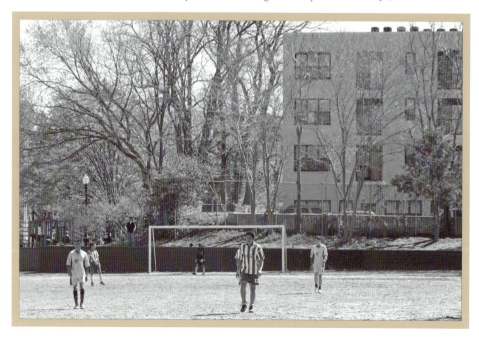

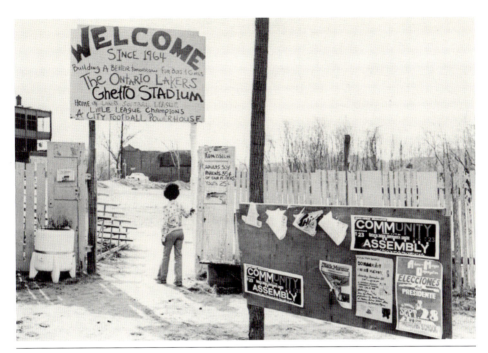

Much about Adams Morgan can be learned from this period photograph, in particular from looking at the bulletin board at right. It is full of announcements of neighborhood meetings, a sign of the activism and community involvement that survives and thrives today. One of the signs is in Spanish, demonstrating the involvement of the Latino community in the neighborhood. One of the posters bears important witness to the now-demolished Morgan School. (Then image copyright *Washington Post*, reprinted by permission of the D.C. Public Library; Now image courtesy Earl Fenwick Jr.)

PLAY

75

That this tango demonstration takes place on ground once destined for residential development. It might not surprise anyone who knows the pressure Adams Morgan has continuously faced from developers. However these dancers, and even modern-day park neighbors, might be surprised to find out that this ground was once a cemetery. First a Quaker burial ground and later the Colored Union Benevolent Cemetery, the human remains in this area were thought to have been relocated to Woodlawn Cemetery. When excavation for residential development unearthed remains, the community forced the developer to shelve the project. (Then image courtesy Nancy Shia; Now image courtesy Earl Fenwick Jr.)

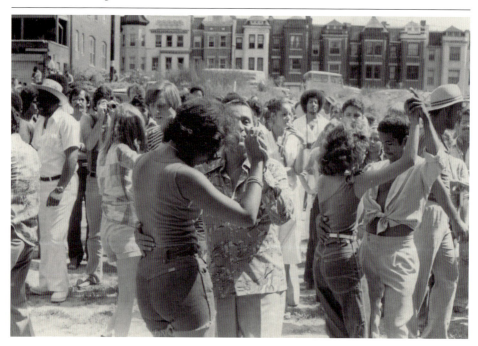

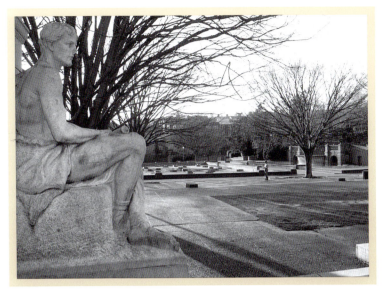

One of Washington's richest collections of exterior statuary (shown here in 1949) graces the 12 acres of Meridian Hill/Malcolm X Park. In addition to this statue and that of Joan of Arc seen elsewhere in these pages, there is an extensive memorial to America's 15th president, James Buchanan. On opposite ends of the metaphysical spectrum are two additional statues, one entitled *Serenity* and the other of *Inferno* author Dante Alighieri. (Then image copyright *Washington Post*, reprinted by permission of the D.C. Public Library; Now image courtesy Earl Fenwick Jr.)

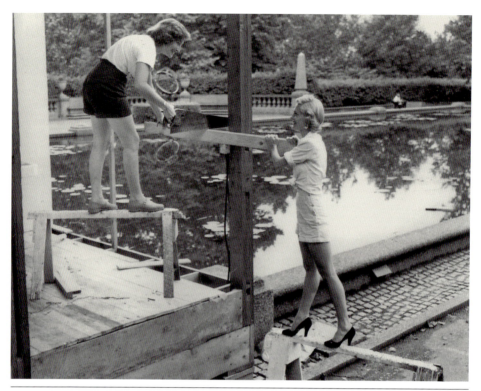

A clotheshorse meets a sawhorse in this 1949 photograph taken in Meridian Hill Park. Two young ladies construct a platform or stage over the park's main basin or pool. In the wake of the Black Power movement, the park was renamed Meridian Hill/Malcolm X Park. (Then image copyright *Washington Post*, reprinted by permission of the D.C. Public Library; Now image courtesy Earl Fenwick Jr.)

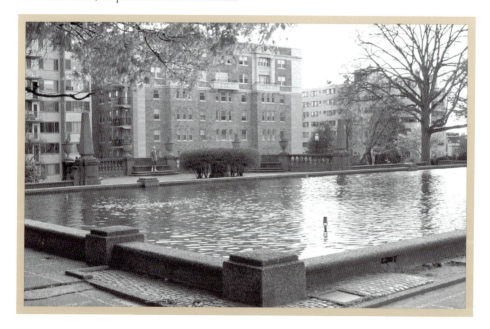

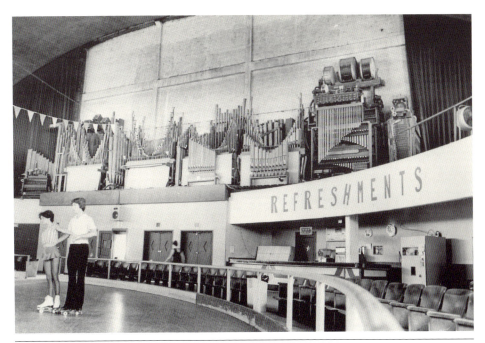

An elaborate organ, drum, xylophone, and chime apparatus looms large over the skating rink at the National Arena. While at the time the building only featured a small refreshment stand, it is currently being remodeled to include an entire supermarket. In between, the building served as a boxing ring, World Wrestling Federation match locale, go-go music venue, Washington National Opera rehearsal space, movie studio (*The Pelican Brief* and *Peggy Sue Got Married* were partially filmed here), and site of the 1994 MTV town hall meeting where Pres. Bill Clinton was infamously asked by 17-year-old Tisha Thompson, "Boxers or briefs?" (Then image copyright *Washington Post*, reprinted by permission of the D.C. Public Library; Now image courtesy Earl Fenwick Jr.)

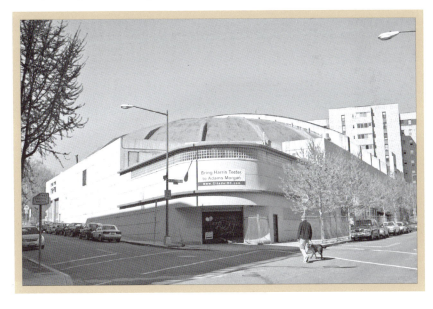

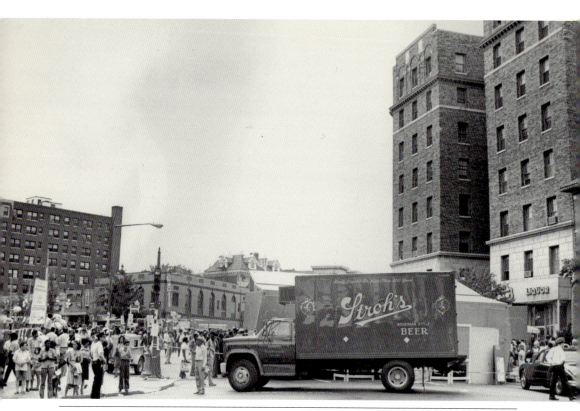

It is difficult for many in the D.C. area to think about Adams Morgan without thinking of Adams Morgan Day. This long-running street festival, nearing its 30th year, has had a number of faces over the years. In its heyday, as pictured here, it was billed as the largest street festival on the East Coast. Today the festival has taken on a more neighborhood-friendly image. The festival has also moved from Columbia Road to Eighteenth Street. Although the festival is now mainly a "dry" event, with alcohol only available inside restaurants and on their patios, this photograph demonstrates that beer is still here. (Then image courtesy Nancy Shia; Now image courtesy Earl Fenwick Jr.)

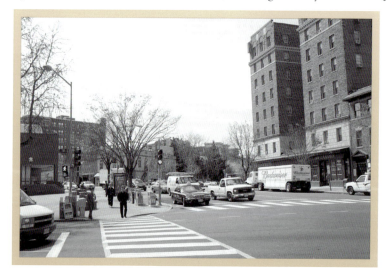

CHAPTER 6

Make History

Though much of the well-known Washington, D.C., history takes place in the blocks immediately surrounding our halls of government, Adams Morgan holds its own in this department. Some events are tragic or nearly so (the collapse of the Knickerbocker Theatre and the attempted assassination of President Reagan at the Washington Hilton). Others, such as the neighborhood's proud history as a hotbed of protest and free thought, remind us of the greatness and complexity of our nation's history of freedom. (Then image courtesy Pat Patrick, personal collection.)

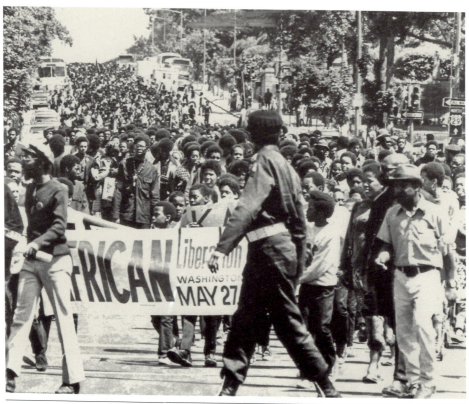

Black Power marchers descend Sixteenth Street past Meridian Hill/Malcolm X Park. The park has long been the site of liberal political activism—African American, Native American, environmentalist, and anti-war. A weekly drum circle plays to this day in the park. (Then image copyright *Washington Post*, reprinted by permission of the D.C. Public Library; Now image courtesy Earl Fenwick Jr.)

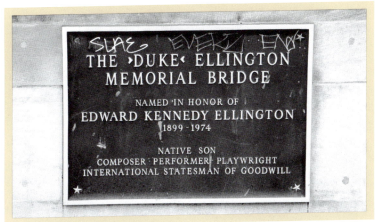

One of two landmark Adams Morgan bridges "puts up its Dukes" in this 1986 photograph. Government officials look on as plaques commemorating native Washingtonian Duke Ellington are unveiled. Ironically while "The A Train" could cross this bridge's precursor and this same bridge at an earlier time, by the time the Ellington Bridge moniker was adopted, the streetcar was long dead, and the bridge only served cars and pedestrians. (Then image copyright *Washington Post*, reprinted by permission of the D.C. Public Library; Now image courtesy Earl Fenwick Jr.)

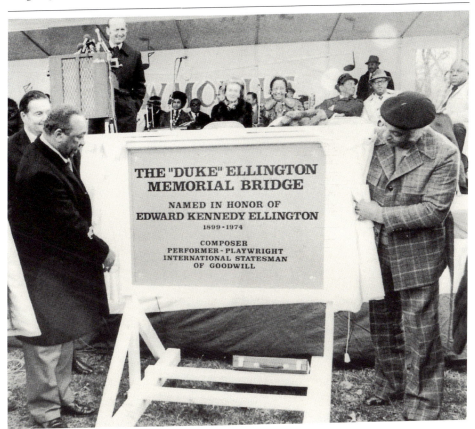

Hearses, emergency vehicles, and gawkers surround the scene of the tragic 1922 roof collapse at the Knickerbocker Theatre. The building was reborn as the Ambassador Theatre, where the movie *The Blob* was shown, Jimi Hendrix played four August 1967 concerts, and writer and social critic Norman Mailer is famously but falsely rumored to have urinated on stage. After a bilingual neighborhood protest defeated a gas station planned for the former theater site, the community advocated successfully for the bank and farmer's market at this location today. (Then image Washingtoniana Division, D.C. Public Library; Now image courtesy Earl Fenwick Jr.)

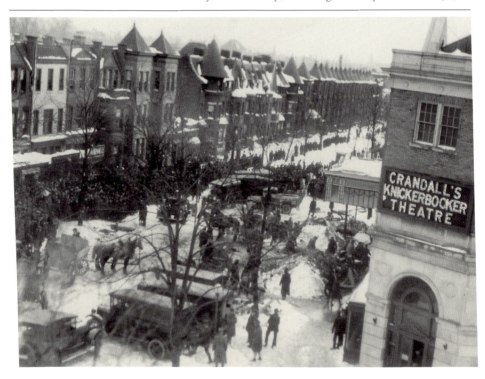

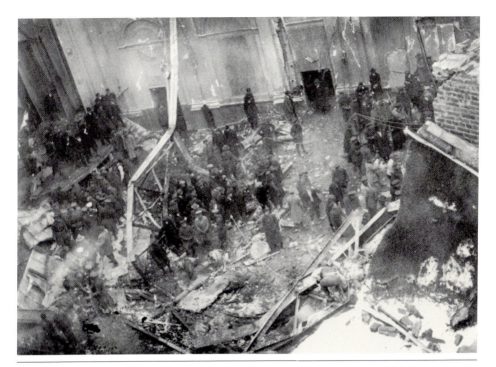

The scene of what is still today Washington, D.C.,'s greatest single-day loss of life greets rescuers at the scene of the collapsed Knickerbocker Theatre. Located at the southwest corner of the key Eighteenth Street and Columbia Road intersection, this 1,700-seat theater and movie house was showing *Get Rich Quick Wallingford* during a historic 28-inch snowstorm on January 28, 1922, when the roof collapsed, killing 98 people. (Then image Washingtoniana Division, D.C. Public Library; Now image courtesy Earl Fenwick Jr.)

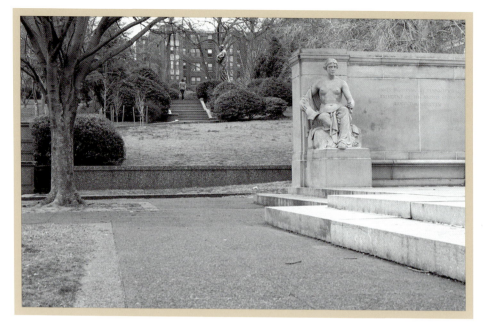

A young Rev. Walter Fauntroy Jr. addresses a crowd at a Black Power rally in Meridian Hill/Malcolm X Park. Fauntroy went on to become the first D.C. delegate to the U.S. House of Representatives since Reconstruction, serving 10 terms. (Then image copyright *Washington Post*, reprinted by permission of the D.C. Public Library; Now image courtesy Earl Fenwick Jr.)

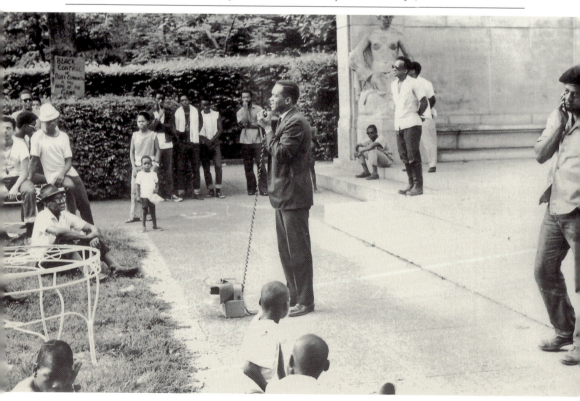

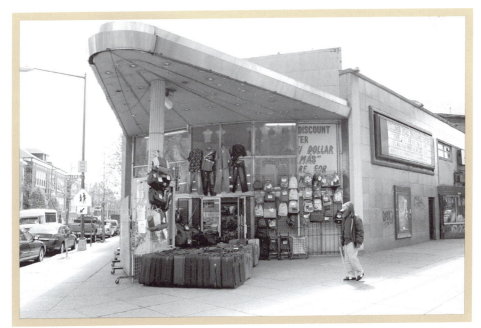

Another of Adams Morgan's dearly departed and missed theaters is the Ontario. At various times in its existence, it was home to first-run films, Spanish-language films, and concerts. In the 1960s, it was home to long showings of *The Sound of Music*, *Funny Girl*, *Mary Poppins*, and *Breakfast at Tiffany's*. In the late 1970s and early 1980s, it hosted concerts by soon-to-be-superstars like U2, the Police, REM, and the Clash. Today it houses a discount clothing and luggage store, but many of the old theater trappings are still visible. As always, a protest is visible in the foreground of the older photograph. (Then image courtesy Nancy Shia; Now image courtesy Earl Fenwick Jr.)

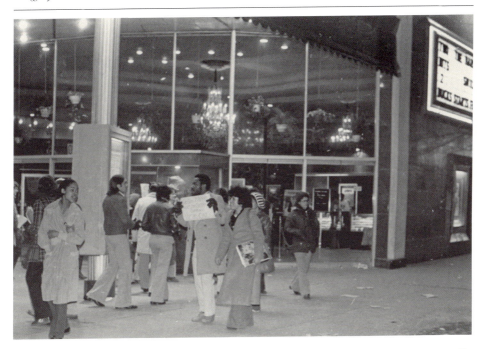

MAKE HISTORY

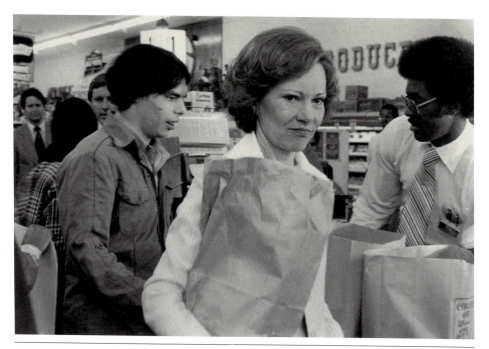

First Lady Rosslyn Carter is seen at a photo opportunity in the Giant on Columbia Road. For many years, until the demolition of the Giant, Columbia Road was home to one of, if not the only, side-by-side placements of a Safeway and a Giant supermarket. The former Giant site is home to a variety of smaller chain stores, but a rumored development would have the adjacent Safeway expanding into the ground floor of a planned mixed-use building. (Then image courtesy Nancy Shia; Now image courtesy Earl Fenwick Jr.)

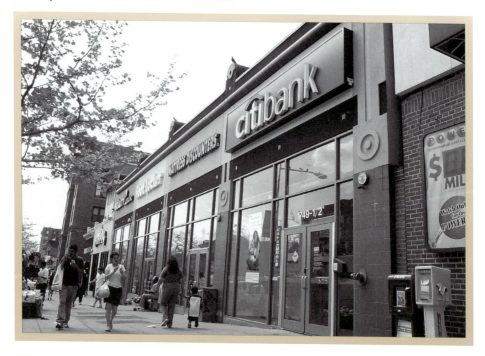

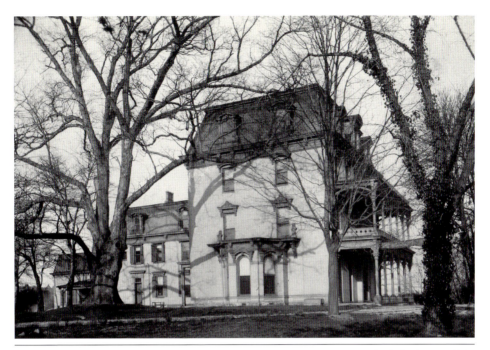

Although a Masonic temple once planned for this site never came to fruition, Temple Heights nonetheless was this neighborhood's moniker for decades. The home pictured here was dubbed Oak Lawn in honor of the mammoth, centuries-old Treaty Oak. Oak Lawn was home to Thomas P. Morgan, late-19th-century D.C. commissioner and namesake of the Morgan School. Subsequent to the tragic elimination of both the home and the tree, the site was considered for a massive mixed-use development designed by Frank Lloyd Wright before ending up as the Hilton. The curvilinear Hilton was the site of the 1981 assassination attempt on Pres. Ronald Reagan. (Then image Washingtoniana Division, D.C. Public Library; Now image courtesy Earl Fenwick Jr.)

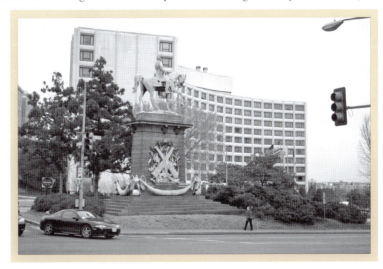

Then–*Washington Post* publisher Eugene Meyer, who lived in the home at the left, had the old Henderson Castle demolished because it was being used to host boisterous, late-night parties. Meyer's home is now part of the museum and academic hub called the Meridian International Center. The apartment at rear is the Envoy. Only the castle's outer walls remain, surrounding the gated, modern townhouse community Beekman Place. (Then image Washingtoniana Division, D.C. Public Library; Now image courtesy Earl Fenwick Jr.)

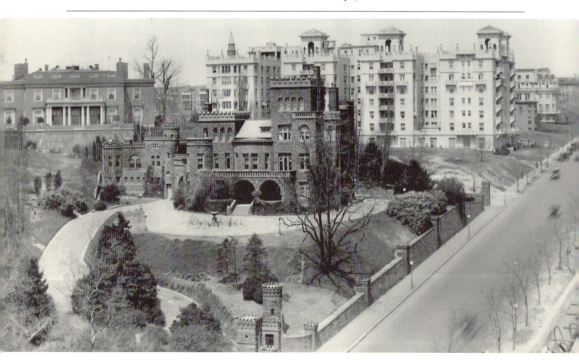

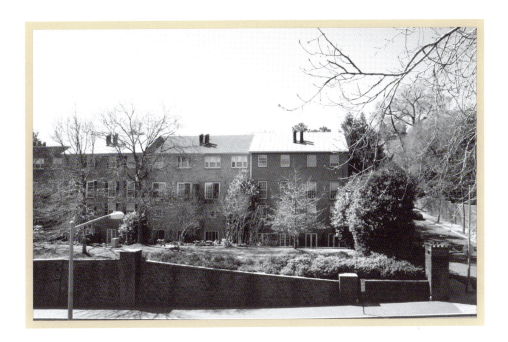

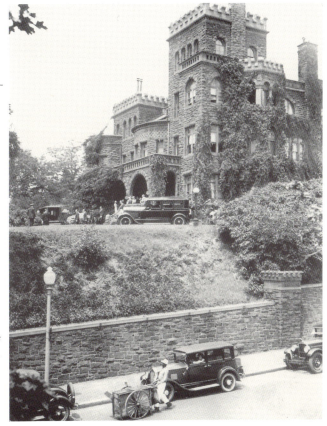

Vendors and vintage vehicles line the street in front of the old Henderson Castle. Constructed in 1888 at the request of Mary Foote Henderson, the wife of a Missouri senator, this stunning brownstone castle once cut an imposing silhouette on the city's border. The Henderson Castle was the flagship of Henderson's efforts to attract high society to Sixteenth Street, including American aristocrats and embassies from Europe and Latin America. The castle was demolished in 1949. (Then image Washingtoniana Division, D.C. Public Library; Now image courtesy Earl Fenwick Jr.)

MAKE HISTORY

An unidentified reader considers the implications of this World War II headline as he walks toward the Polish Embassy, one of many embassies coaxed to locate on this stretch of Sixteenth Street by Mary Foote Henderson. Other than the security camera seen at left, the modern-day photograph could have also been taken during the World War II era. (Then image copyright *Washington Post*, reprinted by permission of the D.C. Public Library; Now image courtesy Earl Fenwick Jr.)

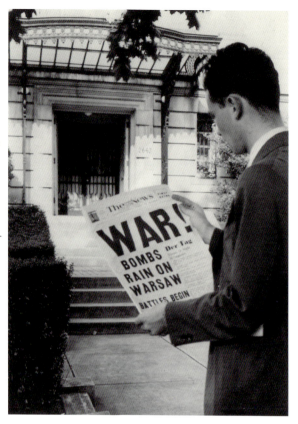

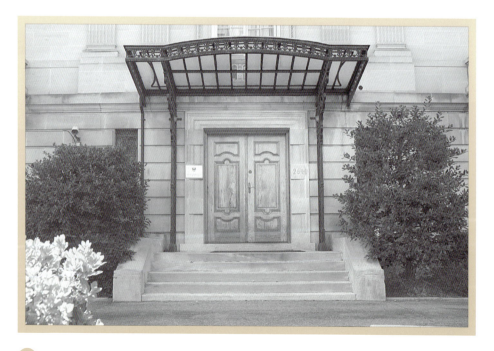

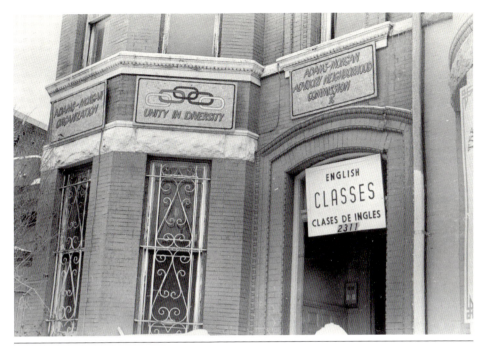

In this late 1970s photograph, an Eighteenth Street storefront is a civic headquarters of sorts. The office is home to the offices of the Adams Morgan Organization and Advisory Neighborhood Commission (ANC) at 1C 2311 Eighteenth Street N.W. ANCs are uniquely Washingtonian political institutions—elected, volunteer neighborhood councils whose opinions on issues such as zoning and liquor licensing must be taken with "great weight" by the city government. The ANCs were created in the late 1970s during the creation of home rule, when political control first began to return to the city from the federal government, and were based on the example set by the Adams Morgan Organization. "Unity in Diversity" was a neighborhood slogan at the time. (Then image courtesy Nancy Shia; Now image courtesy Earl Fenwick Jr.)

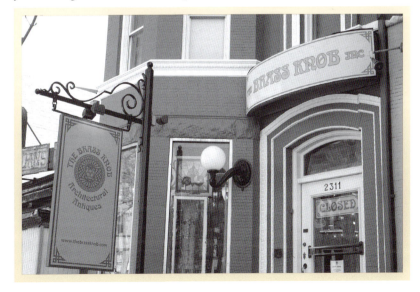

Between its life as a movie and live-music theater and its current use as a bank and a farmer's market, the corner of Eighteenth Street and Columbia Road was planned to become a British Petroleum (BP) gas station. The idea did not go over well with residents. It is thought that these were some of the first bilingual protests in Washington. Many neighborhood activists and at least one future District Council member cut their teeth on this protest. (Then image courtesy Nancy Shia; Now image courtesy Earl Fenwick Jr.)

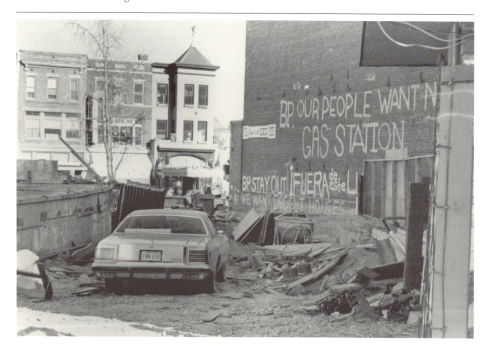

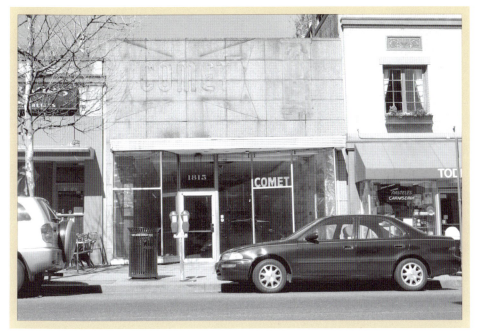

Columbia Road was once a key festival and parade center for the District. Adams Morgan Day took place on Columbia Road, as did the city's Latino Festival. While Adams Morgan Day moved just around the corner to Eighteenth Street, the Latino Festival's popularity and desire for maximum prominence led organizers to move it downtown. On this Latino Festival float, activists fight for the future of the Kenesaw Cooperative, which did survive, just north of Adams Morgan on Sixteenth Street. (Then image courtesy Nancy Shia; Now image courtesy Earl Fenwick Jr.)

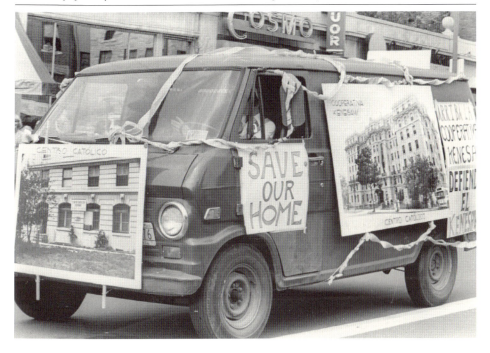

Discover Thousands of Local History Books Featuring Millions of Vintage Images

Arcadia Publishing, the leading local history publisher in the United States, is committed to making history accessible and meaningful through publishing books that celebrate and preserve the heritage of America's people and places.

Find more books like this at
www.arcadiapublishing.com

Search for your hometown history, your old stomping grounds, and even your favorite sports team.

Consistent with our mission to preserve history on a local level, this book was printed in South Carolina on American-made paper and manufactured entirely in the United States. Products carrying the accredited Forest Stewardship Council (FSC) label are printed on 100 percent FSC-certified paper.